CORNELIUS
JOHNSON

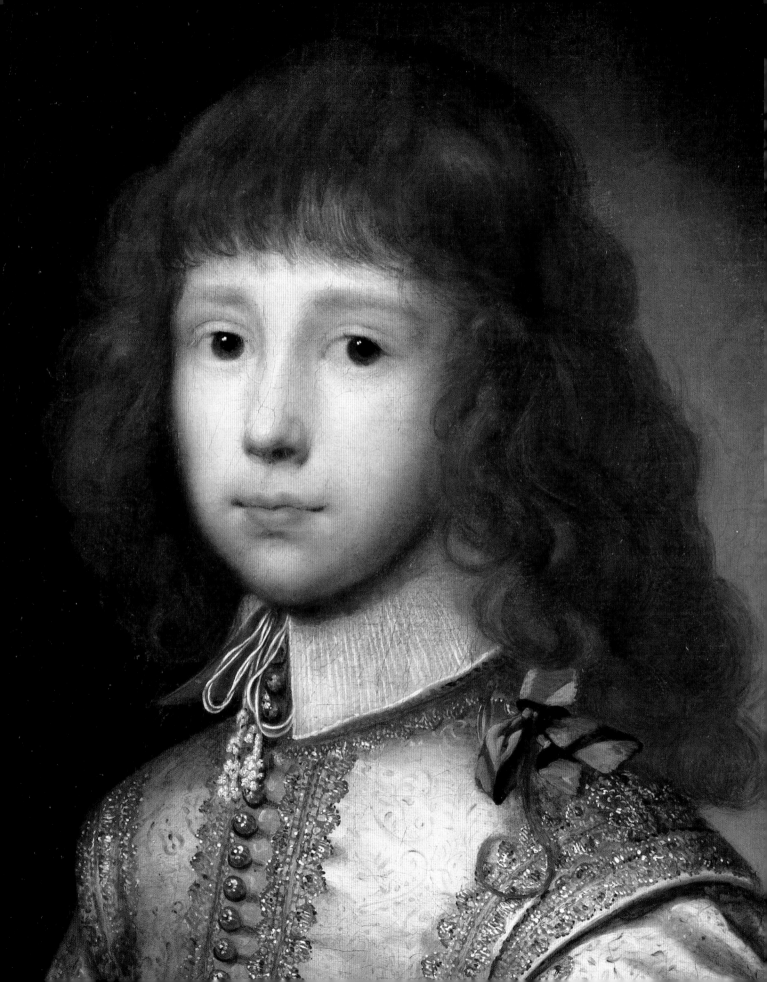

Karen Hearn

CORNELIUS JOHNSON

Paul Holberton publishing

Published with the support of The Gapper Charitable Trust
and The Paul Mellon Centre for Studies in British Art

ISBN 978 1 907372 82 7

British Library Cataloguing in Publication Data

A catalogue record for this book is available from the British Library

Produced by Paul Holberton publishing
89 Borough High Street, London SE1 1NL
www.paul-holberton.net

Designed by Laura Parker
www.parkerinc.co.uk

Origination and printing by
E-graphic, Verona, Italy

FRONT COVER Cornelius Johnson, *Susanna Temple,* 1620 (fig. 5), detail
BACK COVER Coenraet Waumans, 'Cornelius Janssens' (Cornelius Johnson), 1649 (fig. 1)
FRONTISPIECE Cornelius Johnson, *Robert, Lord Bruce,* 1635 (fig. 27), detail
PAGE 6 Cornelius Johnson, *Dorothy Hammond, née Wilde* (?), 1636 (fig. 37), detail

PHOTOGRAPHIC CREDITS

© Amgueddfa Cymru – National Museum of Wales: fig. 20; © Amsterdam City Archives,
Archive of the English Reformed Church (photo: Sander Karst): fig. 39; © British
Library: fig. 48; © Centraal Museum, Utrecht / Ernst Moritz: fig. 50; © Christies Images
Ltd 2015: fig. 30, 35, 38; © City Collection of Middelburg (photo: Art in Print): fig. 44;
© Collection Rijksmuseum Twenthe, Enschede (photo: R. Klein Gotink): figs. 31, 46;
© College of Arms, London: fig. 2; © Frederick & Kathryn Uhde (Photo: Colin White): fig. 37;
© The Hague Historical Museum, The Hague: fig. 42; © J. Paul Getty Museum: fig. 49;
© Kupferstichkabinett, Berlin: fig. 52; © National Portrait Gallery, London: figs. 17–19, 34;
© National Trust: fig. 43; © Rijksmuseum, Amsterdam: fig. 33; © Royal Collection Trust /
© Her Majesty Queen Elizabeth II 2015: fig. 13; © The Sackville Collection at Knole (photo:
Colin White): fig. 47; courtesy of Sotheby's: fig. 16; © The Suffolk Collection, English
Heritage: figs. 12, 25, 27; © Tate, London 2015: figs. 5, 24, 40, 41; © The Trustees of the
British Museum: fig. 50; © Devonshire Collection, Chatsworth. Reproduced by permission
of Chatsworth Settlement Trustees: figs. 15, 23; © The Trustees of Lamport Hall: fig. 3;
© Walker Art Gallery, Liverpool: fig. 4; courtesy of The Weiss Gallery, London: figs. 7, 8,
10, 11, 14, 22, 26, 28, 29, 32; © The Weston Park Foundation, Staffordshire: fig. 21; © Yale
Center for British Art, Paul Mellon Collection: fig. 6

Acknowledgements

OVER THE YEARS THAT I HAVE BEEN STUDYING JOHNSON
and his career, I have received assistance from many people. They include:
Marco van Baalen, Peter Barber, Marten Jan Bok, Claire Browne, An van
Camp, Claire and Richard Gapper, Sabine Craft-Giepmans, Keith Cunliffe,
Jessica David, Timothy Duke (Norroy and Ulster King at Arms), Rudi
Ekkart, Emilie E.S. Gordenker, Sir John Guinness, Jan de la Hayze, Katie
Heyning, Louisa Howard, Manfred Huiskes, Richard Johns, Rica Jones,
Marie de Lauzon, Sander Karst, Paul Knolle, Catharine MacLeod, John
Matthews, A.C. Meijer, Norbert Middelkoop, the late Sir Oliver Millar,
Susan Morris, Susan North, Daniel Obbink, Julian Opie, Paul Petzold, Ruud
Priem, Nigel Ramsay, Lord Sackville, Anja Sevcik, Clementine Sinclair,
Jan Six, Edward Town, Frederick and Kathryn Uhde, Natasha Walker, Bert
Watteeuw and Mark and Catherine Weiss. The late Walter Liedtke gave me
wise counsel on Johnson as well as on other Anglo-Netherlandish topics.

I am grateful to Sandy Nairne, former Director of the National Portrait
Gallery, London, for inviting me to curate a display there on Johnson
(15 April – 13 September 2015). I would also like to thank the Amsterdam
'schildersclub' for their longstanding friendship and help: Jonathan Bikker,
Lia Gorter, Frauke Laarmann-Westdijk, Hanneke Verschuur and especially
Michiel Franken.

My research on Johnson has benefitted from the help and resources of
many institutions: Amsterdam City Archives, CODART, the Hamilton Kerr
Institute, Kent Local History Centre at Canterbury, London Metropolitan
Archives, The National Archives, The Portland Collection, the marvellous
staff of the Heinz Library & Archive at the National Portrait Gallery, the
archives of Sir Oliver Millar and Sir Ellis Waterhouse at the Paul Mellon
Centre in London, Rijksmuseum Twenthe at Enschede, my colleagues in
the Department of English Language and Literature at University College
London, Tate Britain, Rijksarchief Utrecht, the Witt Library, Yale Center
for British Art at New Haven, and the Zeeuwsarchief, Middelburg. Many
of the owners of the photographs reproduced in this volume have been
exceptionally kind and helpful, among them particularly The Weiss Gallery.

Thank you to Laura and Paul at Paul Holberton publishing. For their
generous grants towards this publication, I am enormously grateful to
The Gapper Charitable Trust and to The Paul Mellon Centre, London.

This book is dedicated, with love and thanks, to my mother Audrey Hearn.

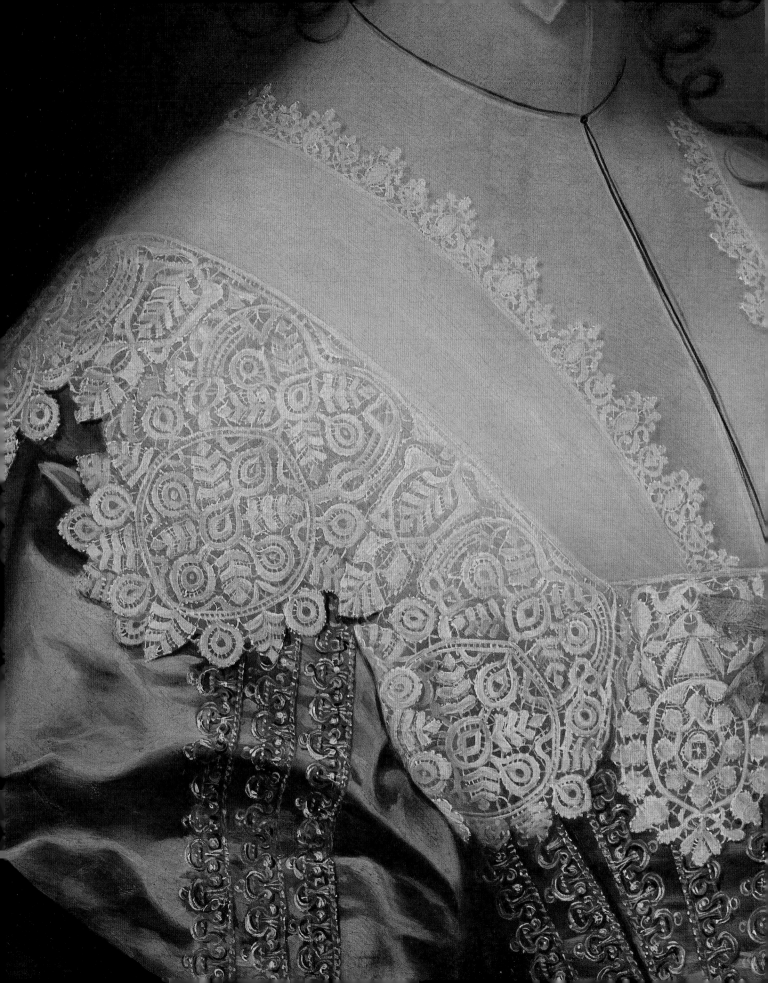

CORNELIUS JOHNSON
Charles I's Other Portrait Painter

PROLIFIC AND SUCCESSFUL IN HIS OWN LIFETIME, Cornelius Johnson (1593–1661) is now the forgotten man of seventeenth-century British art (fig. 1). His surviving works – all of which are portraits, plus a handful of portrait-related drawings – are found in most public collections in Britain (often, it must be said, in their stores, rather than on display) and in many private collections – seen on the walls of British country houses, in the possession of descendants of the original sitters.

Although he lived and worked in Britain and the Netherlands, Johnson has been surprisingly neglected in both British and Dutch art history. This is the first book to focus solely on Johnson and his work. As a painter at the English Court, he had the misfortune first to be overshadowed by the superstar Antony van Dyck (1599–1641) and then to find his English career curtailed by the Civil Wars. British art historians have rarely addressed his work, perhaps unwilling to have to tackle his Dutch-period works too; while Dutch scholars seldom seem interested in his earlier, quarter-century-long career in England. Indeed, it was only in 2012 that the first English-period works by Johnson entered a Dutch public collection.[1]

To art historians in the Netherlands – where Johnson spent the final eighteen years of his life – he is known as 'Cornelis Jonson van Ceulen', but in the present book, for consistency, he will be referred to throughout as 'Cornelius Johnson', which is the form of signature that he used on his early paintings.[2]

Introduction

Johnson was born into a Flemish/German immigrant family in 1593 in London. His baptism there is recorded in the records of Austin Friars, the London Reformed church attended by Protestant migrants from Continental Europe – often colloquially known as the 'Dutch church'.[3] The next known documentary reference to him occurs in January 1619, when he witnessed the baptism of a

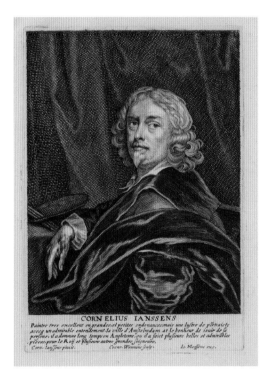

1

COENRAET WAUMANS
AFTER CORNELIUS JOHNSON
'Cornelius Ianssens' (Cornelius Johnson), engraving in Jan Meyssens, *Images de divers hommes d'esprit sublime ...*, 1649, reprinted in Cornelis de Bie, *Het Gulden Cabinet*, Antwerp, 1662

nephew in London.[4] His earliest known paintings also date from 1619. He became extremely prolific, with his sitters coming from the various upper levels of society, and in 1632 he was appointed one of King Charles I's painters. In 1643, following the outbreak of the Civil Wars in Britain, and the consequent failure of court patronage, Johnson and his family moved to the United Provinces (the northern Netherlands). There, he joined the Guild of St Luke, the painters' guild, in the commercially thriving coastal city of Middelburg, in Zeeland. References to his presence in Middelburg recur during the 1640s and early 1650s.[5] He also lived in Amsterdam and worked in The Hague. He seems finally to have settled in Utrecht early in the 1650s, and was a leading portrait painter there until his death. He was buried in Utrecht on 5 August 1661.

His only surviving son, who was also named Cornelius, was born in London in 1634.[6] He, too, practised as a painter in the Netherlands, and was buried in Utrecht in 1715.[7] He evidently assisted his father.

Johnson worked on every scale, from the tiny oval miniature to the full-length and the large group portrait. His earliest works are on wooden panel, and, although during the 1620s he also began to paint on canvas, panel paintings occur even among his later works. Johnson was the first British-born artist to sign his paintings as a matter of course, and he generally dated them as well. During his British years, especially, he seems to have used different styles of painting for portraits produced at the same time. However, although he constantly, subtly modified his style of presentation, his portraits are in general easily recognizable. The sitter's head is often placed unexpectedly low in the frame. The range of poses is limited. There is a meticulous precision in the handling of jewellery and of dress – above all, of the lace collars that were such signifiers of rank and wealth in early seventeenth-century Britain and Holland. The handling of his sitters' eyes is often particularly distinctive – with enlarged, rounded irises, and deep, curved upper lids.

English or Dutch (or even German)?

For centuries there was retrospective confusion as to whether Johnson could be designated an English or a Dutch artist. As a consequence, writers have called him by numerous forms of name. The peripatetic German artist and author Joachim von Sandrart (1606–1688), in an account published in Latin in 1683 but written earlier, correctly described Johnson as a Flemish Londoner, and stated that his parents, who had been born in the Spanish part of Belgium, had moved to London as a result of the conflict in the Low Countries, and that their son Cornelius had been born following the move.[8]

Late sixteenth-century London was full of exiles from Continental Europe, many of whom were Protestants escaping

the re-Catholicization of the southern Netherlandish provinces. There had been one such migration in the late 1560s, following the Duke of Alva's repression of Netherlandish rebellion against the Spanish Habsburg monarchy. Then, in 1585, the Spanish army had recaptured the city of Antwerp, and again many Protestant merchants and craftspeople had departed, either for the northern Netherlands or for other Protestant havens such as Elizabethan England.

In 1706 the British writer Bainbrigg Buckeridge referred to "Cornelius Johnson alias Jansens" as a Dutch artist (that is, one from the northern Netherlandish provinces) in a short, fifteen-line biography of him:

> ... an excellent Painter both in great and little, but above all his portraits were admirably well performed. He was born in, and resided a long while at Amsterdam, from whence he came over to England in the reign of king James I [he] was contemporary with Vandyck, but the greater fame of that master soon eclipsed his merits; though it must be owned his pictures had more of neat finishing, smooth Painting, and labour in drapery throughout the whole; yet he wanted the true notion of English beauty, and that freedom of draught which the other was master of.

Buckeridge was wrong in saying that Johnson was born in Amsterdam, but, on the basis of a study of his technique, it is likely that Johnson received at least some of his training in the northern Netherlands.[9]

The *Dictionary of National Biography* in 1908 called the artist "Cornelius Janssen van Ceulen".[10] More recently, the UK Public Catalogue Foundation has called him "Cornelis Janssens van Ceulen" (as, indeed, does Wikipedia), although this is not a form of signature that he seems ever to have used.[11] Johnson himself must inadvertently take some responsibility for the confusion, because at different times, and in the different places in which he worked, he varied the monograms and forms of signature that he applied to his portraits. The way in which Johnson deployed his differing national identities in the art market will be examined further below.

In 1634 the Heralds at the College of Arms in London confirmed that Johnson was entitled to bear arms, registering a five-generation pedigree that named his great-grandfather as "Peter Johnson of Cullen" – that is, of Cologne (fig. 2).[12] According to this, his grandparents were "John Johnson of the citty of Antwerpe" and "E[u]phemia van Cuchelan", and his parents were "Cornelius Johnson of Antwerpe" and "Jane [Johanna] le Grand". This pedigree is the main surviving evidence of the family's origins.

The arms are, in heraldic terminology, "Or, three popinjays vert" – in other words, three green parrots on a gold ground. There is

2

Cornelius Johnson's pedigree in the Visitation of London 1633–35 made by Sir Henry St George, Richmond Herald College of Arms, London, MS C24 fol.608

also an elaborate crest, consisting of two green parrot wings behind a silver Catherine wheel: "On a wreath in front of two wings vert a Catherine wheel argent". In the sketch at the head of the visitation pedigree, the birds in the arms and the wings are described as both "vert" and "proper", meaning 'in their natural colours'. Winged crests are apparently common in Germanic heraldry, which suggests that the arms may have originated thus far back in family usage, although they could have been gained subsequently in Antwerp.[13] Though they were probably 'burgher arms' (a form of arms not given in Britain), they were clearly accepted by the British heralds as noble arms.

Interestingly, it seems the artist's father may have carried out secret service work for Sir Thomas Walsingham, in Dunkirk and other towns in the Low Countries – various payments for which are recorded in 1589, 1590 and 1592.[14]

Johnson's Cologne ancestry is significant, because after he migrated to the Netherlands he chose to word the signature that he applied to his paintings (from about 1652 onwards) 'Cornelis Jonson van Ceulen' – that is, 'of Cologne'. Indeed if one looks up Johnson in the index to a Dutch publication, one needs to do that under the letter 'C' (for 'van Ceulen'), rather than 'J'.

Although only a small amount of biographical information on Johnson's life survives – gleaned mainly from official documents and from church records – some portraits of him are known (see figs. 1, 31 and 51). They consistently depict a plump, successful and apparently jovial figure.

Johnson's training: his possible teachers in London and the Netherlands

It has not so far proved possible to establish where, and with whom, Johnson received his artistic training. Conventionally, he would have begun his apprenticeship around the age of fourteen, although in Britain this seems to have been more flexible than on the Continent. Scant information on this is available, however, because almost no pre-1624 records for the London Painter Stainers' Company have survived.

Johnson would have been fourteen in 1607–08. More than a century later, George Vertue, the engraver and recorder of art-world history, wrote (as had Buckeridge before him) that Johnson had come to London from Amsterdam in 1618.[15] Vertue stated that his source was Johnson's great-nephew, the little-known British painter Anthony Russel (or Roussell) (c. 1663–1743). This could confirm that Johnson had received some training in Amsterdam. There is at least one other example of an English youth of Netherlandish origins being sent back there for training. In April 1613 a Michiel Austine, resident in London, apprenticed his son Nataniel to the Amsterdam painter Jan Teunissen for five years, "in order to learn painting".[16]

Other portrait painters who were active in the city from about
1607 include Pieter Joachim (1609–14), Abraham Urich (1610–19),
Adriaen van Nieuwlandt (from 1609), Jan Tengvogel (1611–35) and
Cornelis Ketel (but he died in 1616, and from 1610 is thought to
have been significantly disabled).[17]

The loss of many of the records in Middelburg has meant that
it has not been possible to explore whether Johnson might have
undergone some training there with, say, its leading portrait
painter Salomon Mesdach (active 1617–32).[18]

It has been suggested that Johnson may also have received
some training in the London studio of Marcus Gheeraerts II
(1561/2–1636), who was by then the official portraitist to
James I's queen, Anne of Denmark.[19] Gheeraerts was well
known to Johnson's family, and indeed witnessed the baptism
of Johnson's niece Elizabeth Russel in 1612. Some portraits by
Gheeraerts bear inscriptions in a distinctive form of lettering. This
can be seen, for example on his portrait of *Catherine Killigrew, Lady
Jermyn*, 1614 (Yale Center for British Art, New Haven).[20] A somewhat
similar script appears on many of the early surviving works signed
by Johnson, including those dated 1619, such as the portraits of Sir
Thomas Boothby and his wife Anne,[21] and of an unidentified elderly
lady (fig. 3) and gentleman, both at Lamport Hall. Most of his
early head-and-shoulders portraits are seen as if through a feigned
stone (or just possibly wooden) oval, which echoes the format of
portrait engravings, especially those that were imported from the
Low Countries, or produced by Netherlandish engravers working in
England. These fictive apertures also echo the oval shape generally
used for portrait miniatures in early seventeenth-century England.

Johnson's very earliest paintings vary surprisingly in appearance;
many, such as the portrait of an *Unknown lady* (formerly thought
to depict Alathea Talbot, Countess of Arundel), dated 1619 (fig. 6),
look more English in their handling – linear and brightly lit, with a
polished surface – than Dutch. They can be compared with certain
early works by the English-born John Hoskins (c. 1595–1665).
His portraits of *Sir Hamon* and *Alice, Lady L'Estrange*, for example
– for which he was paid £4 in 1617[22] – both include a dark-brown
feigned stone oval similar to the type used by Johnson. According to
Buckeridge, Hoskins was "bred a Face Painter in oil, but afterwards
taking to miniature he far exceeded what he did before" – and,
indeed, Hoskins did turn to miniature painting, for which he used
the customary water-bound pigments on vellum.[23] His portrait
miniature of *Catherine Howard, Countess of Salisbury*, of about 1620
(private collection),[24] can be compared with Johnson's portrait of
Susanna Temple, signed and dated 1620 (fig. 5); there are similarities
in the ovoid shape given to the head and in the polished handling
of the flesh. It is not known with which oil-painter Hoskins trained,
either, although Marcus Gheeraerts II, again, and (perhaps less
plausibly) William Larkin (c. 1580–1619) have been suggested.[25]

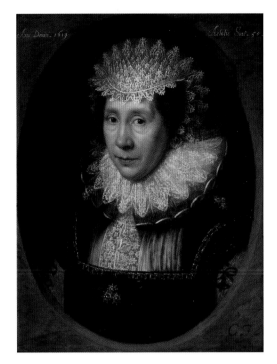

3
CORNELIUS JOHNSON
Unknown elderly lady, 1619
Oil on panel, 62 × 45.5 cm
Lamport Hall, Northampton

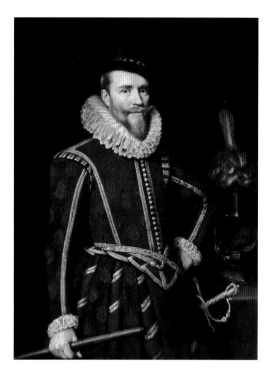

4

MICHIEL JANSZ VAN MIEREVELT
*Edward Cecil, later Viscount
Wimbledon*, 1610
Oil on panel, 113.4 × 85 cm
Walker Art Gallery, Liverpool

5

CORNELIUS JOHNSON
*Susanna Temple, later Lady
Lister*, 1620
Oil on oak, 67.9 × 51.8 cm
Tate

I must stress again how rare it was for painters in Britain up to this time to sign their works. Johnson could have brought this unusual habit back from a period of training in the northern Netherlands. Overall, the likeliest candidates for his master would have been either the Hague-based Jan Anthonisz van Ravesteyn (c. 1572–1657) or the Delft-based Michiel Jansz van Mierevelt (1566–1641).[26] When George Vertue saw a portrait of *Edward Cecil, Viscount Wimbledon*, dated 1610, at Somerset House – probably the one in fig. 4, which is now known to be by Van Mierevelt – he identified its painter as Johnson.[27] Indeed, the "neat finishing and smooth painting" ascribed to Johnson by Buckeridge would equally describe the works produced in the van Mierevelt studio.

The art market in London in 1619

When Johnson returned to London in 1618 or very early 1619, the market there was still principally one for portraits. It was, however, something of a transitional moment. The leading English-born and -trained Court portraitists Robert Peake I (born c. 1551) and William Larkin (born 1580s) were both to die during 1619, as did the miniature painter Nicholas Hilliard (born c. 1547), whose chief rival, Isaac Oliver (born c. 1560/5), had died two years previously.[28] (Oliver had been made godfather to Johnson's nephew Isaac in 1616, and his widow was, like Johnson himself, a witness at the baptism of Johnson's younger nephew Nicasius Russel in January 1619.) The principal painters in London were now, moreover, second-generation Netherlandish migrants, such as Marcus Gheeraerts II, who had been born in Bruges but brought to England in around 1568 by his exiled Protestant father, and Gheeraerts's brother-in-law John de Critz I (c. 1551/52–1642), born in Antwerp but largely trained in London among the Netherlandish incomer community there.

It is clear that these painters ran busy London studios or workshops with a number of personnel, and that collaborations between practitioners were common, although evidence as to how exactly this worked is lacking. All these artists were being superseded in fashion, however, by a handful of younger, recently arrived painters who had been both born and trained in the Netherlands. Paul van Somer, born in Antwerp in about 1576, was in London by December 1616. In the five years before his death there at the very end of 1621, he became the favoured image-maker of James I's queen, Anne of Denmark, until her own death early in 1619, and soon of the king himself.[29] Another Netherlandish painter who worked briefly in London, between 1617 and 1622, was Abraham van Blijenberch (died Antwerp 1624), painter of a number of the Court elite.[30]

The most prolific, and longest-lasting, of these incomer portraitists was Daniel Mytens (c. 1590–1647), who was born

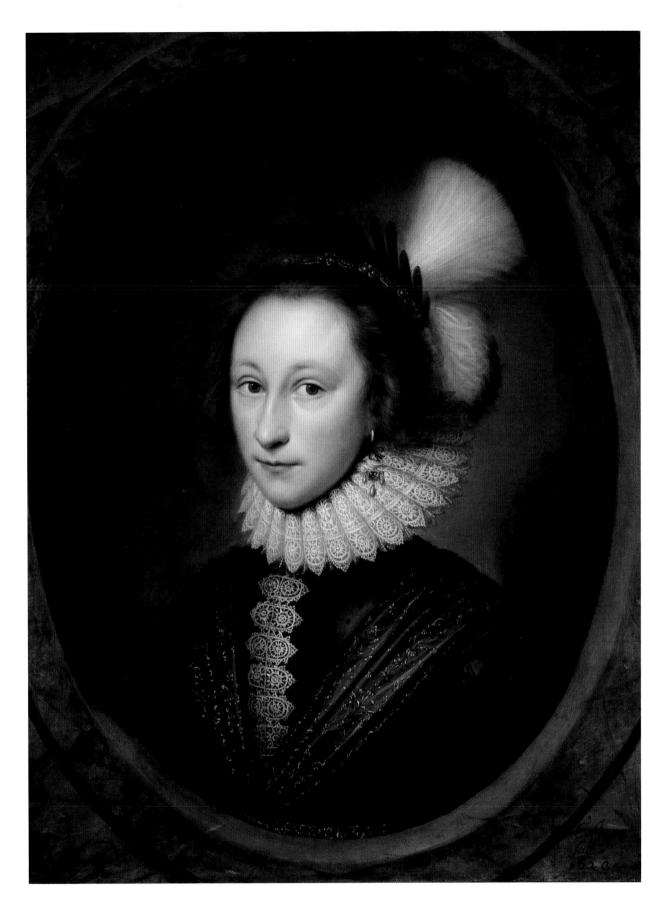

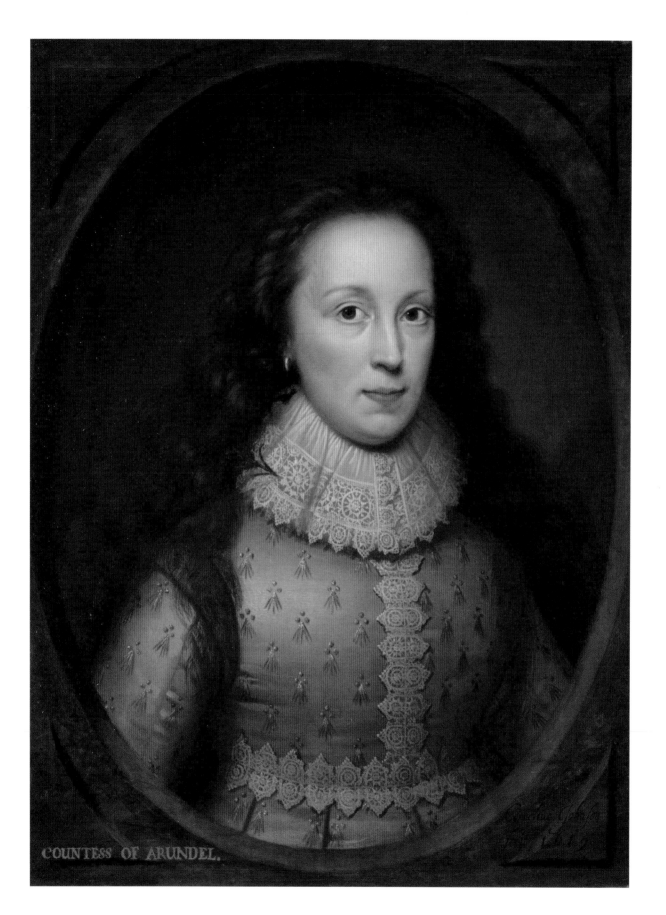

COUNTESS OF ARUNDEL.

14

into a family of artists in Delft, and joined the Guild of St Luke, the artists' guild, at The Hague in 1610. Mytens was in London by August 1618, already working for the sophisticated art collectors the 14th Earl and Countess of Arundel. He first portrayed James I in 1621, and in 1624 James awarded him an annual pension. At his accession, Charles I appointed Mytens his "picture-drawer" for life, and for a number of years thereafter there were regular payments to him for portraits for official use.[31] In due course, however, supplanted by van Dyck, he would return to The Hague in 1634.

There were a number of other Netherlandish painters at court, not all of whom were portrait specialists. They included Hendrick van Steenwijck the Younger (c. 1580–1649), who was in London by November 1617, and remained there for the next twenty years. He specialized in (usually small) architectural scenes, generally darkly lit and ostensibly illustrating biblical stories.[32]

Johnson would thus have been very aware that there were fresh opportunities at the top of the market, especially for Netherlandish-trained painters.

Johnson's early portraits, his patrons and clients

Johnson's earliest surviving works, dated 1619, are, as mentioned, almost all oval head-and-shoulders portraits of individual sitters in feigned ovals. This format seems to have been a popular one in England from the start of the seventeenth century onwards. So when Johnson returned there, he evidently embraced it – and, of course, a head-and-shoulders portrait was comparatively quick to paint, and therefore cost less to commission – a good strategy for an artist entering a new market.

Among the early works are the two signed portraits, dated 1619, of an *Unknown elderly gentleman* and an *Unknown elderly lady* (fig. 3), on which he used a monogram form of signature in the bottom right spandrel: *C.J.* On a few other portraits dated 1619, his signature includes a smaller 'C' impaled on a large 'J' – *Ɉ fecit / 1619.*

It has been suggested that some of these early pictures may be of related sitters. A few, with early 1620s dates, are certainly of members of the Temple family.[33] Occasionally, the same portrait survives in more than one version, such as the one of *Sir Alexander Temple* (versions at Hagley Hall, Worcestershire, and Yale Center for British Art, New Haven). Some are rather ostentatiously signed, again in the bottom right spandrel: *Cornelius Johnson fecit,* and dated – for example, the portrait of an *Unknown lady* formerly thought to depict Alathea Talbot (fig. 6).[34]

A pair of portraits by Johnson which are dated 1619, of *Sir Thomas Boothby* and his wife *Anne Grafton*, look, on the other hand, extraordinarily Dutch, both in presentation and in paint handling (figs. 7 and 8).[35]

CORNELIUS JOHNSON
Unknown lady (traditionally identified as *Alathea Talbot, Countess of Arundel*), 1619
Oil on panel, 73.7 × 66 cm
Yale Center for British Art, New Haven

7

CORNELIUS JOHNSON
Sir Thomas Boothby, 1619
Oil on panel, 109.2 × 85 cm
Private collection

In 1622, at the time of his marriage to Elizabeth Beck (or Beke or Beek), who was from a migrant family based in Colchester (which also had a large Dutch community), Johnson was living in the London parish of St Ann, Blackfriars.[36] In the map in John Norden's 1593 *Speculum Britanniae* (fig. 9), the parish can be seen on the northern bank of the river Thames, above the letter 'A' in *THAMYS*. Outside the jurisdiction of the Guilds of the City of London, Blackfriars was popular with immigrant craftsmen of many different trades. Johnson would therefore have been part of a mutually supportive immigrant community network. Other incomer

8

CORNELIUS JOHNSON
Anne Grafton, 1619
Oil on panel, 109.2 × 85 cm
Private collection

artists residing there had included the miniaturists Isaac Oliver
(1565–1617) and his son Peter (c. 1589–1647) – and later Alexander
Cooper (1609–1660), who studied under Peter Oliver – as well as the
miniaturist David des Granges (c. 1611–c. 1672), who, like Johnson,
also painted on a larger scale. Another resident was Nicasius
Russel (1567–1640), formerly of Bruges, who in 1604 had married
Johnson's sister Clara.[37] One of the couple's sons, Theodore (1614–
1689), was also to become a painter, and is said to have trained
with Johnson. Nicasius was a successful goldsmith and jeweller
who supplied the Court; he could have been a source of excellent

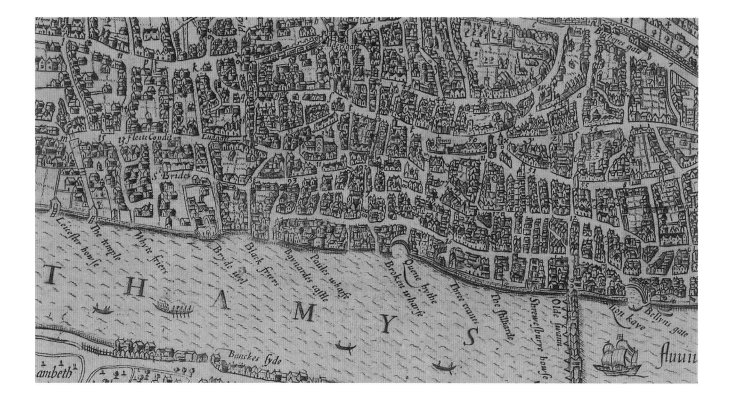

9

Map of London, engraved by
Pieter van den Keere, in John
Norden's *Speculum Britanniae*,
London 1593 (detail showing
Blackfriars, above the 'A' of
THAMYS, where Johnson
lived among a community of
immigrant craftspeople and
merchants)

contacts, and his work might have had a bearing on the way that
Johnson in his English paintings so meticulously delineated the
jewels worn by his sitters.

Throughout the 1620s Johnson was extremely active, producing
portraits for an increasingly elevated clientele, to a remarkably
high technical standard. Like the leading portrait painter to the
Stuart Court Daniel Mytens, he was evidently required to produce
multiple versions of some works. In January 1625 Johnson took
on an apprentice, about whom nothing at present is known other
than his name, recorded as "John Evoms".[38] If this surname is in
fact 'Evans' then this suggests a Welsh or British origin – in other
words not Netherlandish. Later, according to George Vertue,
Johnson's nephew Theodore worked with him, living with him
for nine years. Johnson "taught [him] to paint" and Theodore
"afterwards livd a year with Vandyke. & coppyd his pictures on small
panels".[39] Portraits attributable to Johnson can sometimes vary
greatly in quality, which suggests that at certain periods he made
considerable use of his assistants.

In 1625 Johnson signed and dated what seem to have been his
first full-length portraits, the paired images of Ellis and Hester
Crispe (private collection).[40]

The 1626 subsidy roll records that Johnson's Blackfriars
residence – which presumably contained his studio – was "Goeinge
downe to the Waterside". This is interestingly close to what we know
of the property on the Thames at Blackfriars provided by Charles I

for van Dyck, after the Antwerp-trained star had come back to work for the Court in 1632. In 1635 £20 was spent on making "a new Cawsey way [ten foot broad] and a new paire of Staires" up into van Dyck's garden there, so that the king could go ashore from the royal barge "to see his Paintings in the monethes of Iune and Iuly 1635".[41]

Johnson's most assiduous client seems to have been the lawyer Thomas, 1st Baron Coventry (1578–1640). He evidently sat on a number of occasions, and signed portraits by Johnson survive bearing various dates, the earliest being a three-quarter-length of 1623 (private collection); there is another of 1627 (fig. 10)[42] with a signed replica of 1629 (private collection). A further powerful image of Coventry is dated 1631 (Earl of Clarendon collection), the year before van Dyck's arrival in London,[43] and there is also a half-length of 1634 (private collection) and a final image dated 1639 (National Portrait Gallery, London). Coventry was appointed Lord Keeper by Charles I in 1625, and it is with his hand on the bag of the Great Seal that he was portrayed by Johnson in 1627.

Johnson also painted a number of other senior legal figures, such as Sir John Finch (1584–1660), whom he depicted in several versions in his official white-furred red robes and chain of office.[44] Finch was the MP for Canterbury and he was appointed Lord Chief Justice in 1633 and Lord Keeper in 1640. Johnson portrayed Sir Robert Heath (1575–1649) a number of times,[45] including the version in oil on panel signed and dated 1630 (fig. 11); he was also commissioned to paint Heath's wife and sons.[46] According to Vertue, Johnson painted small paired miniatures of Heath and his wife, too (location now unknown). Head-and-shoulders and half-length portraits of Heath survive in multiple versions, of varying quality. Indeed, it appears that Johnson may have been the painter of choice for individuals who had risen from the 'middling sort' and wished to mark their appointment to senior political or legal office by commissioning a portrait.[47]

Vertue stated that Johnson "generally" charged for "a head five broad peices".[48] It seems, however, that the coin known as a 'broad piece' – which was equivalent to 20 shillings, or £1 – was not minted before 1656. Vertue's source – Johnson's painter great-nephew, who was not born until about 1663 – is presumed to have meant £5. It is also not clear when or for how long Johnson was charging this amount. Late in Johnson's English career, in 1638, Sir Thomas Pelham, of Halland House, Sussex, recorded in his book of disbursements for the "Midsummer Terme", "It[em] pd to Janson for my picture 4.0.0".[49] It has not been possible to establish whether this portrait has survived, but an old photograph of what may be a copy after it shows an oval head-and-shoulders image.[50] To make such comparisons is probably misleading, but in April 1630 Charles I's principal portrait painter Daniel Mytens was paid £60 for a full-length portrait of the king.[51]

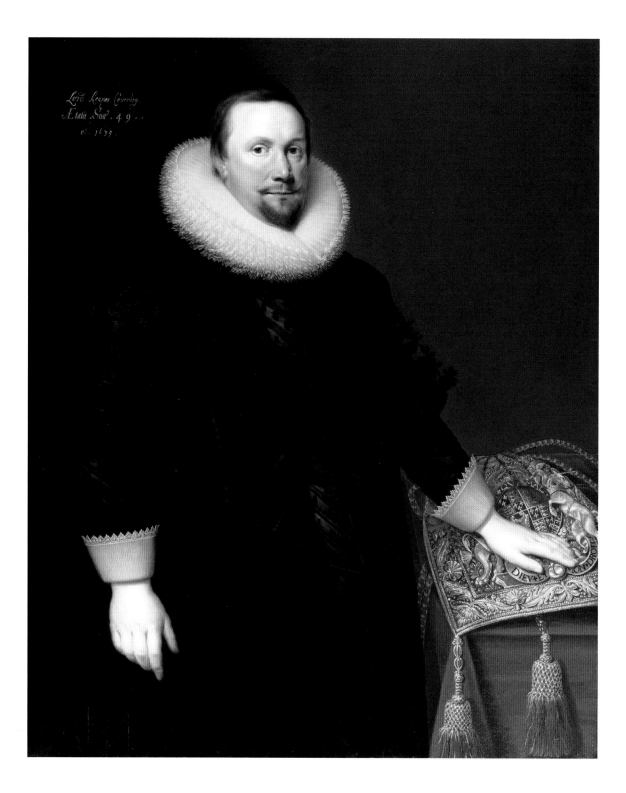

10

CORNELIUS JOHNSON
Thomas, 1st Baron Coventry,
Lord Keeper of the Great Seal, 1627
Oil on canvas, 118.8 × 97.8 cm
Private collection

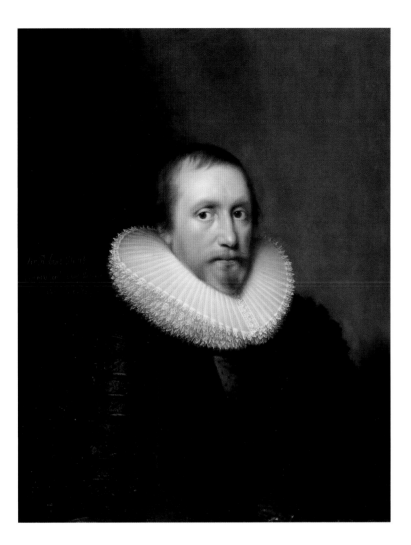

11

CORNELIUS JOHNSON
*Sir Robert Heath, Lord Chief
Justice of England*, 1630
Oil on panel, 78.8 × 62.2 cm
Private collection

Johnson painted the new French ambassador to London, Charles de l'Aubespine, Marquis de Chateauneuf-sur-Cher (1580–1653), soon after his arrival in London in July 1629. The ambassador had been sent by Louis XIII to impede the diplomatic efforts of the Flemish painter Peter Paul Rubens, who was at Charles I's Court to promote the cause of peace between Britain and Spain and the Spanish Netherlands. Johnson depicted him in a black jacket and elaborate ruff, wearing the Order of the Saint-Esprit.[52]

Johnson's portrait of *Lady Margaret Hungerford*, 1631, is inscribed with his characteristic signature of this time, *CJ Fecit / 1631* (fig. 12). Margaret (died 1672) was the daughter of a wealthy London alderman, William Halliday, and had married Sir Edward Hungerford in 1621. Based at Corsham House in Wiltshire and Farleigh Hungerford Castle in Somerset, the couple also owned estates in Gloucestershire and Berkshire. The painting is typical of the sumptuous half-length female portraits that Johnson was then producing, conveying every detail of Margaret's extensive and

CORNELIUS JOHNSON
Lady Margaret Hungerford, 1631
Oil on panel, 78.5 × 61.5 cm
The Suffolk Collection,
English Heritage Trust

costly lace, her embroidered and spangled dress and silver-braided ribbons, as well as of her expensive jewellery (the black stones that she wears are all diamonds). Depicting her attire and lace in such detail would have taken many hours of precise painting.

1631 seems to have been remarkably busy for Johnson, as he signed and dated more paintings that year than any other. He must have been at the height of his success in London at the time. By now, he had settled on a comparatively limited number of portrait poses, which evidently went down well with his particular clientele.

Johnson's role as Picture Drawer to Charles I

As mentioned, at Charles's accession in 1625 Daniel Mytens had been appointed "one of our Picture-Drawers of our Chamber in ordinary". Born in about 1590, Mytens was almost Johnson's exact contemporary, and, like him, may have trained with van Mierevelt, in Delft. Nothing is known about Mytens's London studio and how it functioned, but it was clearly enormously productive. There are, for instance, as many as 22 extant versions or derivations of Mytens's full-length portrait of *James, 2nd Marquis of Hamilton*, which indicates how much studio assistance he must have used.[53]

Mytens and his studio also produced several full-length portraits of Charles I, to a range of patterns, of which a number of variants survive.[54] Intriguingly, one of Mytens's official full-length portraits of the king, dated 1631, is actually signed by Cornelius Johnson – *C.J:fecᵗ. / 1631* (fig. 15).[55] This was exactly the form of signature that Johnson was using on his own portraits at this period, and it suggests that he must have been working, at least some of the time, in collaboration with Mytens. Behind the king, to the left, is a view of Windsor, while, at the king's feet, a spaniel crouches playfully.

A portrait miniature of Charles I, painted in oil on silver, and inscribed on the back with the date 1630 (private collection), is perhaps by Johnson,[56] though it was not until 5 December 1632 that Johnson was appointed "his Majesty's servant in ye quality of Picture Drawer to his Majesty".[57] Earlier that year, in April, the increasingly celebrated Antwerp-born and -trained painter Anthony van Dyck had arrived in London. He had in fact worked there very briefly as a youth, from October 1620 to February 1621 (soon after Johnson's own return to London) but had then left for Italy, where, over some years of working, travel and study of the art that he saw there, he had hugely expanded his repertoire of compositions, adopting a more Titianesque style of portraiture. Van Dyck was very soon knighted by Charles I – and this was only one indication of the value that Charles placed on the visiting painter, who had been Rubens's most admired pupil. Soon after his arrival in spring 1632, van Dyck painted the very large group portrait of Charles I and his family known as the 'Greate Peece' (fig. 13), which revolutionized the representation of the British monarchy by showing the

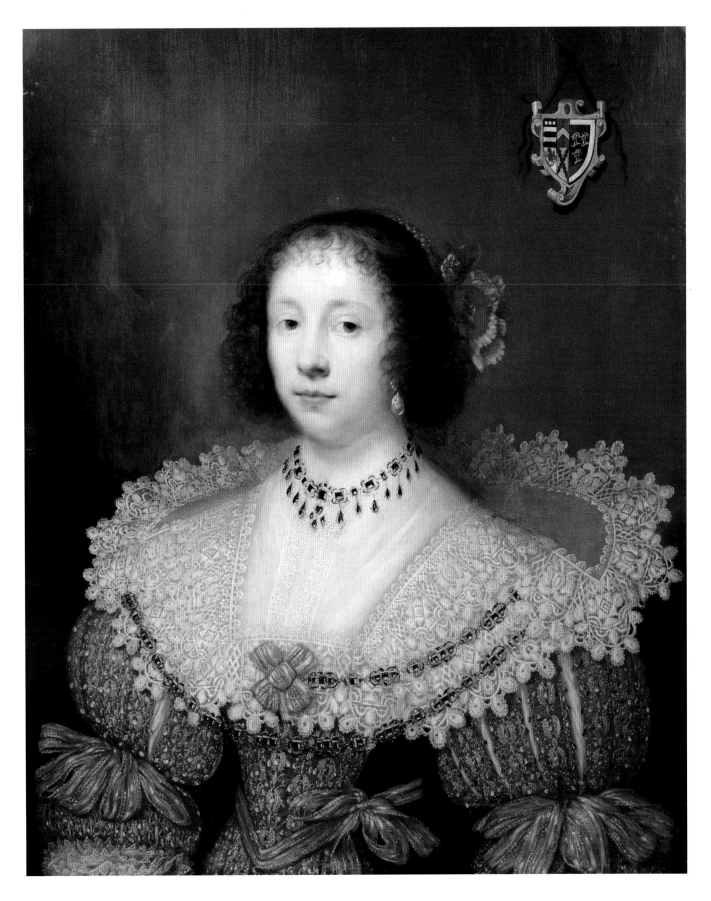

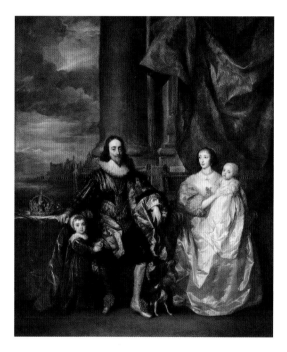

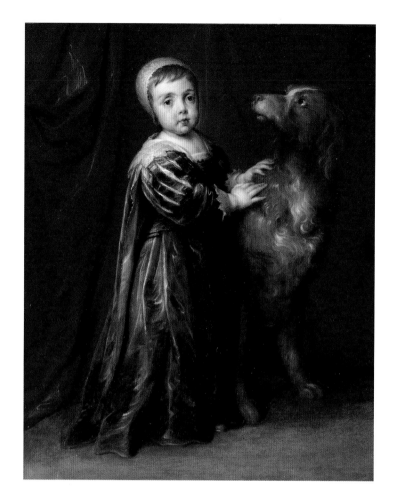

13

ANTHONY VAN DYCK
*Charles I and Henrietta Maria
and their two eldest children*
('The Greate Peece'), 1632
Oil on canvas, 302.9 × 256.9 cm
The Royal Collection

14

CORNELIUS JOHNSON
AFTER VAN DYCK
Charles II as a boy, c. 1632–35
Oil on copper, 25.5 × 21 cm
Private collection

15

CORNELIUS JOHNSON
AFTER DANIEL MYTENS
Charles I, 1631
Oil on canvas, 198 × 119 cm
Chatsworth House,
Derbyshire

king and queen and their children as a stately but affectionate, interconnected unit.[58] It appears that Mytens was very quickly dropped, and a few years later migrated back to the Netherlands.

Van Dyck's contacts in London were, from the outset, at the highest level, and he found instant success and a large elite clientele there. The product that he was offering, combining Flemish Baroque style with Italianate elegance, was radically different from Johnson's.

Indeed, Johnson seems to have received only a few royal commissions – certainly for works on a larger scale. A rather distinguished head-and-shoulders portrait, signed and dated *1633*, is set in Johnson's usual form of feigned oval and depicts Charles I in his Garter cloak, wearing his Garter George hanging from a blue ribbon.[59] Its present location is unknown. Charles seems otherwise to have commissioned from Johnson only small-scale images, both original compositions and miniature copies after extant works by other artists.

This seems evident from two very similar surviving small works on copper, of near-identical size (fig. 14).[60] Though unsigned, they are clearly by Johnson. They copy the figure of the infant

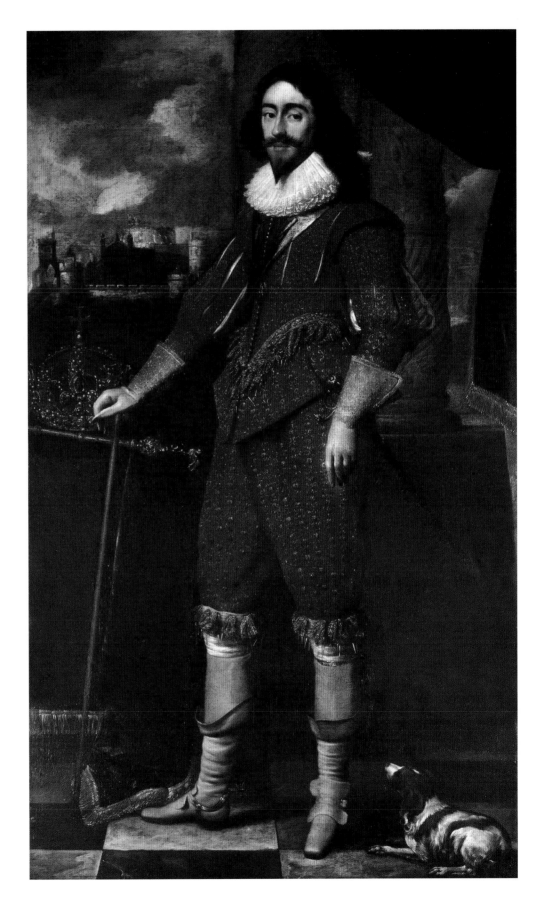

GERARD HOUCKGEEST
AND CORNELIUS JOHNSON
*Henrietta Maria, Queen of
England*, 1637
Oil on panel, 49.5 × 43 cm
Private collection

Charles II from van Dyck's 'Great Peece', although Johnson may not have taken the figure directly from the immense painting itself, but from a now-lost related individual picture of the prince that is thought to have been produced in van Dyck's workshop.[61] Presumably Charles I commissioned these little paintings from Johnson to be given as gifts. In both the prince wears a dress, as was customary at this period for little boys, who were not put into breeches until the age of six or seven. This suggests that they were painted quite soon after the 'Great Peece' itself, because when in 1635 van Dyck portrayed the three eldest children of Charles I – in a portrait to be sent to their aunt, the Duchess of Savoy – and again showed the prince in a skirt, the king was reported to be displeased, considering such babyish attire now inappropriate for an image of his heir.

Labels on the back of one of these small pictures of Prince Charles indicate that it was sold in the major Hamilton Palace auction in July 1882.[62] In a seventeenth-century inventory of the Hamilton collection, the picture was described as "the prince at Length w^{th} a spanniell of ionston".[63] Thus, it is likely that it was a royal gift to James Hamilton, 3rd Marquess and later 1st Duke of Hamilton (1606–1649), who was Charles I's Master of Horse, gentleman of the bedchamber, and whose current *ODNB* entry describes him as the "most important Scot at [Charles's] court". The early provenance of the other version, which is reproduced here, is unknown, but it is particularly delicate in handling.[64]

In 1637 Johnson painted a small full-length of *Charles I,* once again based on a Mytens pattern, set in a fictive architectural setting painted by Hendrick van Steenwijck (Gemäldegalerie Alte Meister, Dresden). Johnson also apparently collaborated with another Netherlandish incomer from The Hague, Gerard Houckgeest (c. 1600–1661) on a similarly small full-length of *Queen Henrietta Maria* (fig. 16). The Queen, a spaniel at her feet, is depicted holding a lute, with an elaborate setting of classical buildings – Houckgeest's contribution – behind her.[65] Both these small paintings were in Charles I's collection and were presumably commissioned by him.[66]

In 1639 Johnson painted three exquisitely detailed small full-length portraits, on oak panel, of Charles I's three eldest children (figs. 17–19).[67] Each child has a carefully chosen open-air scene behind them. Thus, behind Charles, Prince of Wales there is a military exercise in progress; behind little James, Duke of York, who holds a pistol, a hunt is visible; while behind Princess Mary there is a garden with a fountain. The latter two portraits are signed in very small monogram and dated 1639. Evidently, Johnson was still working for the king, albeit on small-scale works. Indeed, in 1641 he was still listed among the king's servants in ordinary of the chamber.[68] When Charles I's collection was dispersed, after his death in 1649, these three paintings, together valued at £6, were in the hands of Johnson's neighbour, the painter Jan Belcam[p].

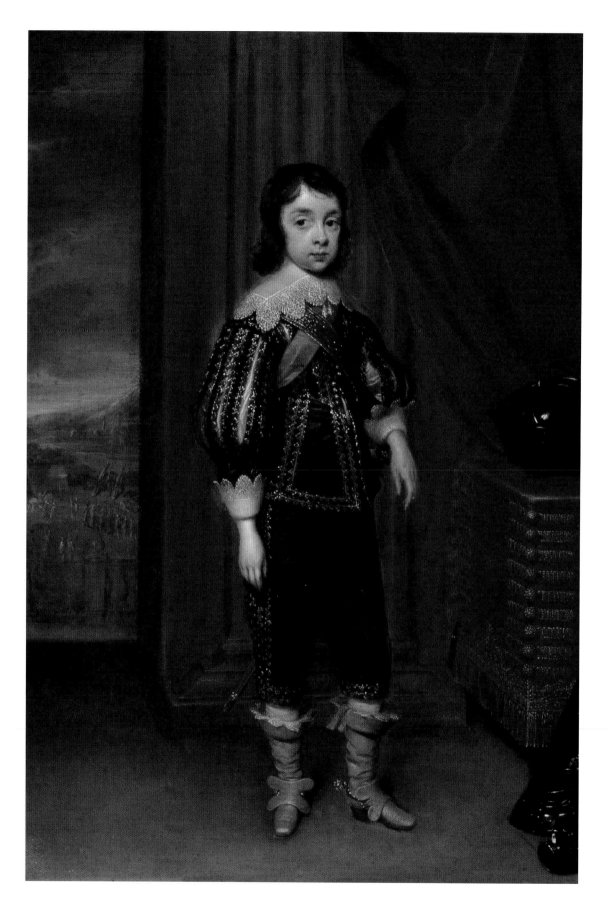

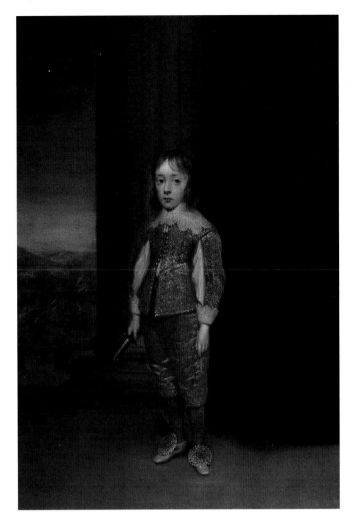

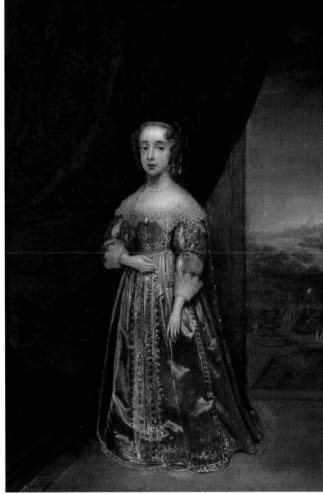

18

CORNELIUS JOHNSON
James II as a boy, 1639
Oil on panel, 28.9 × 20 cm
National Portrait Gallery,
London

19

CORNELIUS JOHNSON
Princess Mary, 1639
Oil on panel, 28.9 × 20 cm
National Portrait Gallery,
London

17

CORNELIUS JOHNSON
Charles II as a boy, 1639
Oil on panel, 29 × 20 cm
National Portrait Gallery,
London

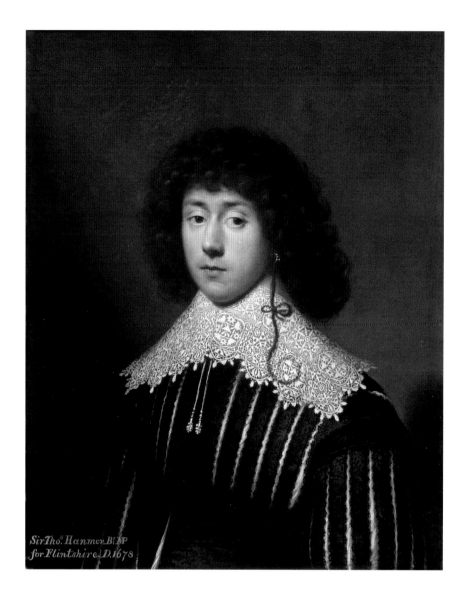

*Sir Thos. Hanmer. Bt. MP
for Flintshire. D.1678*

The impact of Anthony van Dyck

In 1634 the Heralds at the College of Arms had confirmed that
Johnson was entitled to bear arms in Britain. Yet, however
socially and professionally ambitious Johnson may have been, the
overwhelming success of his Blackfriars neighbour van Dyck must
have presented him with a considerable challenge. It is possible
to demonstrate Johnson's problem by comparing his head-and-
shoulders portrait of *Sir Thomas Hanmer*, of 1631 (fig. 20), with van
Dyck's portrait of the same sitter of about seven years later, in
c. 1638 (fig. 21).

Johnson's image of Hanmer (1612–1678) is typical of his work at
this period.[69] It was probably painted around the time of Hanmer's
marriage to Elizabeth Baker, a lady-in-waiting to Queen Henrietta
Maria. Hanmer wears a collar edged with a deep band of cutwork
and needlelace, with knotted bandstrings (all meticulously

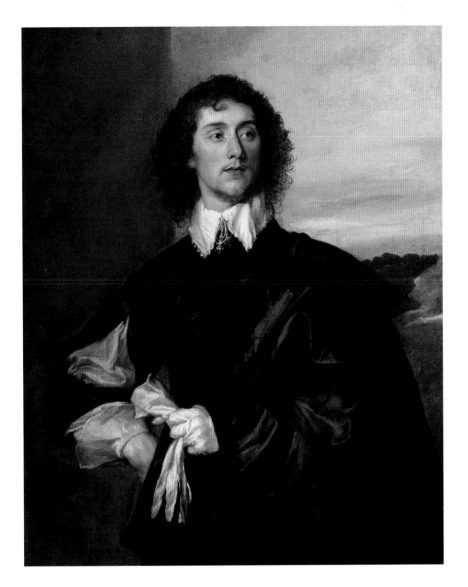

21

ANTHONY VAN DYCK
Sir Thomas Hanmer, c. 1638
Oil on canvas, 117.5 × 85.7 cm
The Weston Park Foundation,
Staffordshire

rendered by Johnson) and a long lovelock, carefully tied with a
red ribbon. It is a highly accomplished and focused portrait, yet it
seems static and self-contained when compared with van Dyck's
Titianesque image of energy, movement and elegance, which,
with its dynamic posture and free and spontaneous brushwork, is
an altogether more glamorous product.[70] Hanmer was a page to
Charles I from 1625 to 1627, and later the king's cupbearer. He also
became an influential gardener and corresponded with some of the
leading horticulturists of the age.

Johnson himself could also bestow a modest glamour, however,
as can be seen particularly in his half-length portrait of an
Unknown gentleman, 1632 (fig. 22).[71] It is unusually animated and
dramatically characterized, which makes it disappointing that the
identity of the sitter, who wears a collar with deep edging of *punto in*

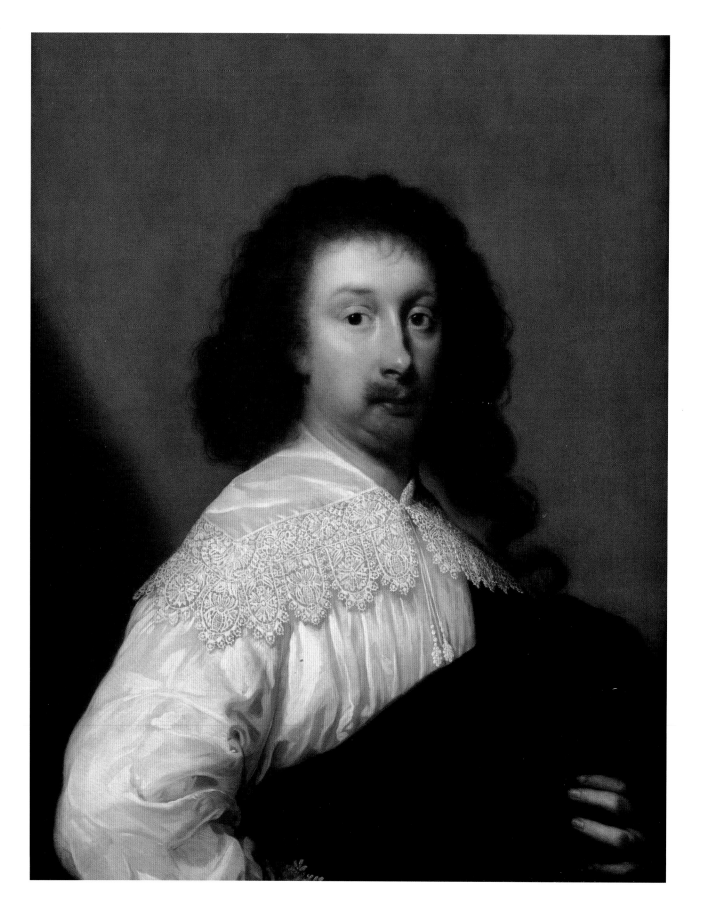

aria and needlelace, is not known, since he presumably played an active role in choosing the manner of his presentation.

Johnson signed and dated this portrait *1632*. It may be his response to the impact of van Dyck's arrival in London in April of that year. (It was unlikely to have been painted before then as a year in seventeenth-century England began and ended with the religious festival Lady Day, thus 1632 began in 25 March.) In its naturalism, however, it also demonstrates an important development of a theme of Johnson's that goes back to at least 1626, in which an individual male sitter is depicted informally dressed, in a voluminous shirt of very fine lawn and a dark cloak, sometimes with his body slightly turned away from the viewer.[72] In fact, it has been suggested that these portraits by Johnson may in turn have influenced van Dyck's later half-length portrayals of James Stuart, 4th Duke of Lennox with his hound, of around 1636.[73] Johnson's image taps directly into the fashionable contemporary iconography of melancholy, in which loosened informal attire signalled intellectual activity and creativity; indeed, occasional portraits of English sitters wearing just a shirt and mantle, by various unidentified artists, survive from as far back as the 1590s.[74]

This elegant *contrapposto* appears in a number of Johnson's male portraits at this period (although not always so successfully). During the 1630s, however, Johnson can be seen increasingly responding to the stimulus of van Dyckian compositions – and not only in his royal portraits. Previously, he seems to have found it difficult to achieve a satisfactory result with life-size full-lengths, as can be seen from the rather underpowered work that is thought to depict the Countess of Sussex, from Boughton House, dated 1630, or the full-length of *Frances Devereux, Marchioness of Hertford* at Petworth.[75] When Johnson borrowed the composition and tone of a work like van Dyck's portrait of *Elizabeth Howard, Countess of Peterborough* (private collection), however, he was able to portray *Diana Cecil, Countess of Elgin* in 1638 with much greater success (fig. 25).[76]

The traffic of influence was certainly not one way. The composition devised by Johnson for a number of male portraits, the *Unknown gentleman* of 1629 (fig. 24), for example, can be identified in van Dyck's portrait of *Lucius Cary, 2nd Viscount Falkland*, c. 1638–40 (fig. 23).[77] Van Dyck must have observed that Johnson's solution was a popular one.

Van Dyck's main perceived effect on Johnson's career can be summed up in Dr Martin Lister's only partly accurate comment, published in 1698, that the Flemish painter's English female sitters were "mighty fond of being painted in *dishabille*. 'Twas this that cut out of business the best English painter of his time, Cornelius Johnson and shortened his life by grief."[78]

22

CORNELIUS JOHNSON
Unknown gentleman, 1632
Oil on canvas, 76.2 × 60.9 cm
The Huntington Library,
Art Collections & Botanical
Gardens, San Marino, CA

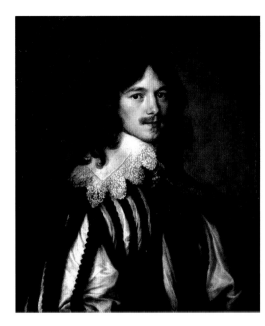

23

ANTHONY VAN DYCK
*Lucius Cary, 2nd Viscount
Falkland*, c. 1638–40
Oil on canvas, 69.9 × 57.8 cm
Chatsworth House,
Derbyshire

24

CORNELIUS JOHNSON
Unknown gentleman, 1629
Oil on oak, 43.5 × 31.8 cm
Tate

25

CORNELIUS JOHNSON
Diana Cecil, Countess of Elgin,
c. 1638
Oil on canvas, 206 × 127 cm
The Suffolk Collection,
English Heritage Trust

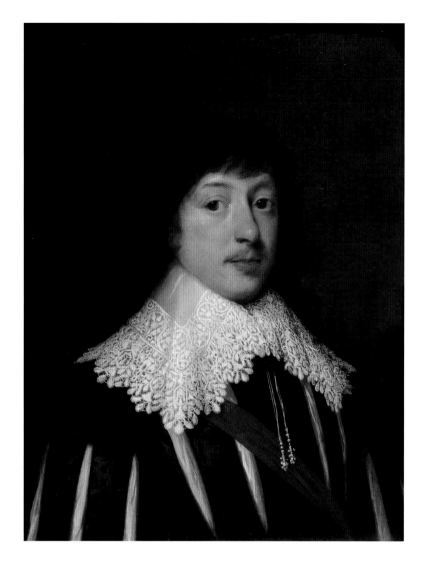

Johnson as a painter of children

A significant number of Johnson's English portraits depict
children, either individually, or in pairs. While this reflects a
general rise in the number of images of children commissioned
by English and Scottish clients from the late sixteenth century
onwards, Johnson may have been seen as particularly good at
producing such portraits. In fact, a childlike effect is conferred
on his sitters of all ages by the unusually large eyes he gives them.
Charles I clearly considered that a good use of his picture-drawer
Johnson was to commission from him small full-length portraits
of the royal children, as discussed above.

In 2014 the Scottish National Portrait Gallery acquired a head-
and-shoulders portrait of a small boy, Robert, Lord Bruce, later
2nd Earl of Elgin (1626–1685), signed and dated by Johnson in
1635, when Robert was about nine years old and when his official
title was Lord Kinross (fig. 26, and see p. 2 for detail).[79] It bears

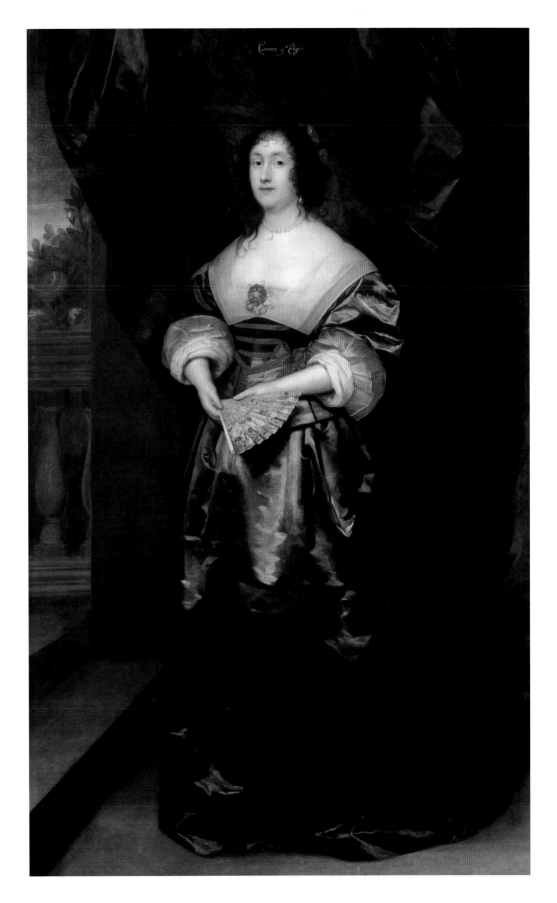

26

CORNELIUS JOHNSON
Robert, Lord Bruce, later 2nd
Earl of Elgin and 1st Earl of
Ailesbury, 1635
Oil on canvas, 73.5 × 62 cm
Scottish National Portrait
Gallery, Edinburgh

27

CORNELIUS JOHNSON
Thomas Bruce, 1st Earl
of Elgin, 1638
Oil on canvas, 210 × 127 cm
The Suffolk Collection,
English Heritage Trust

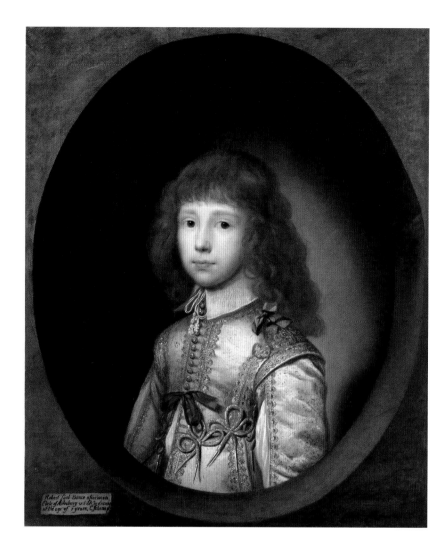

a painted trompe l'oeil label, bottom left, which must have been added late in the seventeenth century.

Robert was the grandson of a Scottish judge who had come south with James VI of Scotland when he became James I of England, and he was the only son and heir of Thomas, Lord Bruce, 1st Earl of Elgin (1599–1663), whose first wife Anne Chichester (1605–1627) had died when her son was an infant. Robert would later make an early form of 'Grand Tour' in Europe from 1642 to 1646 and, on his return, became a royalist (unlike his father), which stood him in good stead at the restoration of Charles II in 1660. He became a Scottish peer in 1663, and is best known as a collector of manuscripts and antiquities, and as an early Fellow of the Royal Society.

Young Robert's portrait was presumably commissioned by his father, and Thomas Bruce must have liked it, because about three years later he went back to Johnson to commission from him full-length portraits of himself (fig. 27) and of his wife, Robert's

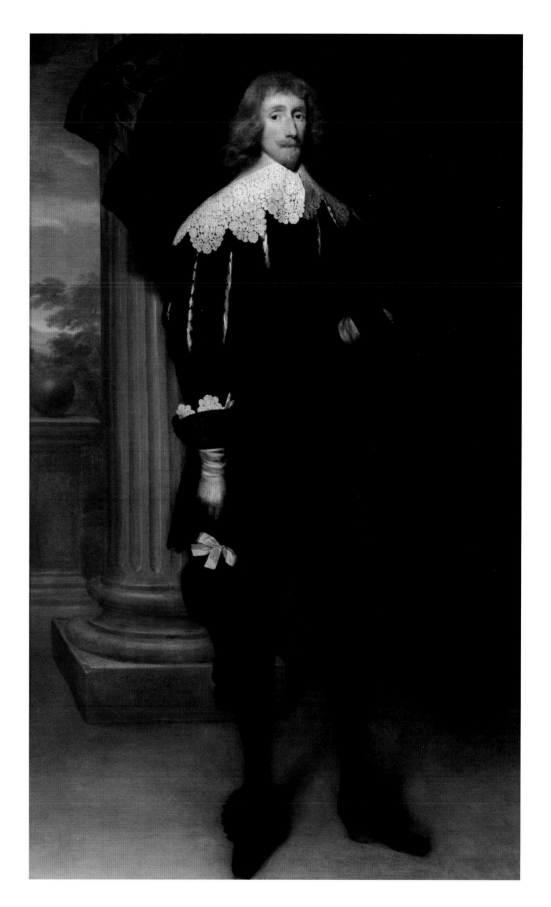

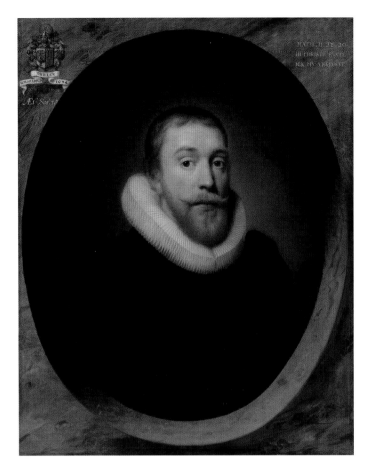
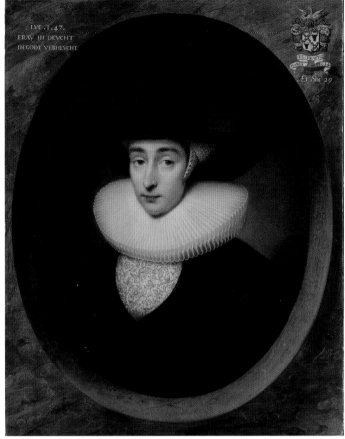

28

CORNELIUS JOHNSON
Willem Thielen, 1634
Oil on panel, 78.7 × 62.7 cm
Museum Catharijneconvent,
Utrecht

29

CORNELIUS JOHNSON
Maria de Fraeye, 1634
Oil on panel, 78.7 × 62.7 cm
Museum Catharijneconvent,
Utrecht

stepmother, Diana Cecil (c. 1603–1654).[80] Male full-length portraits are, in fact, rare in Johnson's work; he appears to have modelled Thomas Bruce's on one of van Dyck's compositions, probably that used for the portrait of *William Cavendish, Earl of Newcastle* of 1637.[81] Diana, who had been the widow of Henry de Vere, 18th Earl of Oxford, was a famous beauty who had married Thomas Bruce in 1629. Her portrait, too, borrows a van Dyck composition, although its striking juxtapositions of colour – scarlet ribbons and roses, and the bright hues of the unfurled fan, against her dark blue satin dress – are distinctively different (fig. 25).

Immigrant clients in London

Research for this book has uncovered the importance for Johnson of the community that centred on Austin Friars, the Dutch church in London. It was where he was baptized in 1593, and where he was married in 1622.[82] It was where so many of his relatives, too, were baptized or married – events witnessed by other family connections and distinguished members of the Netherlandish community in London whom Johnson would also portray.

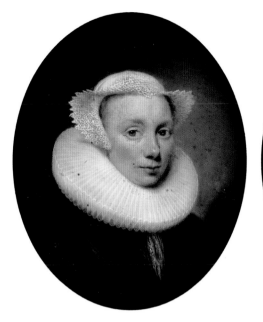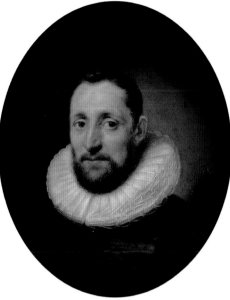

In 1634, for example, Johnson painted Willem Thielen (1596–1638), who had been the Minister of Austin Friars since 1624, and his wife Maria de Fraeye (1605–1682) (figs. 28 and 29).[83] The couple had come from, and had been married in, the Dutch coastal city of Middelburg. Maria de Fraeye's diary, which has recently come to light, is full of detail on the couple's life in London.[84]

The subsequent wills of Theoderick (or Dierick) Hoste and Jane Hoste (née Desmaistres), whom Johnson depicted in a pair of miniatures in 1628 (fig. 30), would indicate that they were linked by both friendship and kinship with Johnson's family.[85] Indeed, Jane Desmaistres (or van Meteren) (1596–1661) was Johnson's first cousin – her mother was his aunt Mary le Grand (1575–1641). Like the Johnsons, the Desmaistres family had originally come from Cologne. In 1613, in London, Jane married the wealthy Dierick (1588–1663), who came from a Flemish family that had migrated north to the Dutch coastal city of Middelburg.[86]

Dierick, a Calvinist merchant and financier, became a member of the British East India Company in 1615 and in 1625 was among a group of Dutch and Flemish merchants who supplied the Spanish king with products for ports in Africa. His customers included the royal physician Dr Theodore Turquet de Mayerne. In 1627 he was elected deacon of the Dutch Church, and an elder in 1628; he thus followed in the footsteps of his father, who had regularly served the Reformed Church in Middelburg in the same capacity between 1597 and 1605.[87] Dierick's will, dated 28 November 1662, indicates that he owned a number of properties in Middelburg and two London houses. Indeed, he seems to have visited Middelburg regularly. He was recorded as being there in 1643–45 and again in 1651–52, at the same time as Johnson. The will also mentions

30

CORNELIUS JOHNSON
Dierick Hoste and his wife
Jane Hoste, née Desmaistres, 1628
Oil on copper, each 95 × 70 mm
Whereabouts unknown

a number of family portraits, including the two miniatures by Johnson: "[To] Brother and sister Hans and Isabella Hoste two small pictures of me and my wife, on condition that they go to my son James after their death".

A second pair of miniatures in oil paint on copper depict the couple's daughter Sarah and her husband Peter Vandeput, who were married on 7 December 1637 (Thomson Collection, Art Gallery of Ontario).[88] Peter was the son of Giles and Sarah Vandeput, whose family had come to London from Antwerp and settled in the City of London. The Vandeputs and their neighbours the Desmaistres (Johnson's kin) were said to be the richest families in the area. Shortly before his death in 1669, Peter arranged for £10,000 to be settled on his wife, to pass afterwards to his son, while his daughter Jane received £4,000.

On 16 December 1638, the names of Johnson and his wife appeared in a 'List of members of the London-Dutch Church'.[89] They were listed in the neighbourhood (wyck) of "Mr Dieric Hoste", along with the painter Jan Belcam[p] and the wife of Dr Mayerne.

Meanwhile, other substantial property holders in Blackfriars included the French Huguenot de Laune (or de Lawne) family, a number of whose members were painted by Johnson. His portrait of the hugely wealthy Royal Apothecary, and associate of Dr Mayerne, Gideon de Laune (1565–1659) is dated *1635*.[90]

A good deal more remains to be discovered about Johnson's relationship with the Hague-born painter Adriaan Hanneman (1604–1671), who lived in England from 1626 to 1638.[91] Hanneman is thought to have worked in van Dyck's London studio; certainly, on his return to the northern Netherlands, he helped to introduce van Dyckian compositions at The Hague. While he was in London Hanneman painted a remarkable portrait of Johnson and his wife and son, c. 1637 (fig. 31), which George Vertue subsequently saw in the collection of Anthony Russel, from whom he learnt that Hanneman had, at some time, unsuccessfully courted Johnson's "neice or near relation", and had painted this picture to please Johnson.[92] In this family portrait, Cornelius the Younger is depicted like a little gentleman, his manner of dress similar to that worn by the elite children often portrayed by Johnson himself, while Elizabeth Beck's attire – especially her hat – resembles that worn by the Dutch pastor's wife Maria de Fraeye in her portrait by Johnson of 1634 (fig. 29). Later, back in the Netherlands, Hanneman and Johnson would have a similar clientele, including exiled British noblemen and, in the 1650s, the little Willem III, the son of Princess Mary Stuart and the deceased Stathouder Willem II.

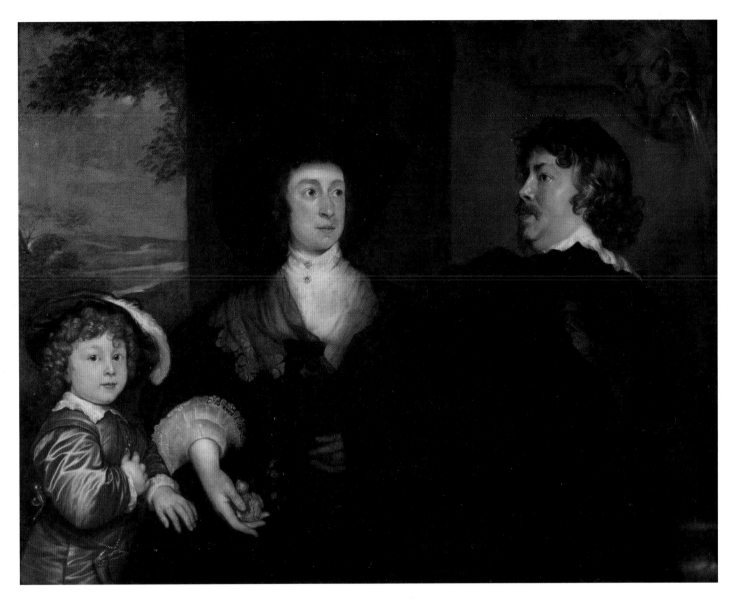

31

ADRIAAN HANNEMAN
*Cornelius Johnson with his
wife and son*, c. 1637
Oil on canvas, 104.5 × 139.5 cm
Rijksmuseum Twenthe,
Enschede

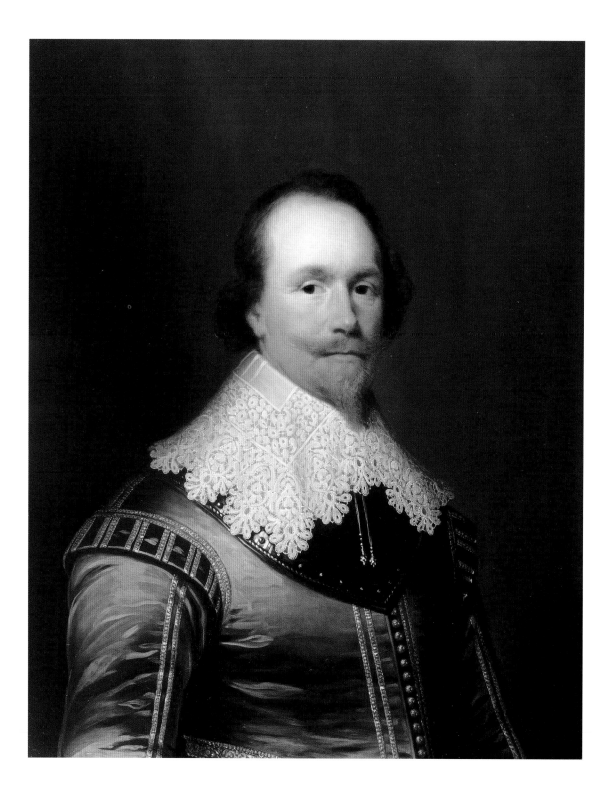

32

CORNELIUS JOHNSON
Peter Courthope, 1631
Oil on panel, 76.5 × 61 cm
Julian Opie collection

Johnson's other patrons and clients during the 1630s and their family and regional links

When in late 1634 or early 1635 the Heralds confirmed that Johnson was entitled to bear arms, they also recorded that he was "of the blackfryers London" (fig. 2). This indicates that George Vertue was incorrect in implying that Johnson left London to live in Kent as early as 1630. It is clear, however, that from the early 1630s onwards Johnson's clients included many sitters – like *Peter Courthope* (fig. 32) – from a group of families living within a comparatively concentrated area near Canterbury – including the Campions of Combwell (fig. 35), the Filmers of East Sutton, and the Oxindens of Deane (fig. 38).[93] Vertue specified that in Kent Johnson "painted pictures for several Gent. Familyes thereabouts – Augers Palmers. Hammond. & Bowyers &c. done mostly in the years 1630 & to 40".[94]

Vertue and subsequent writers have claimed that during the 1630s Johnson dwelt for several years in the house of the wealthy Sir Arnold Braems. According to Walpole, "in 1636 and the next following years [he] resided with Sir Arnold Braems, a Flemish merchant at Bridge, near Canterbury".[95] The details of this arrangement are unclear, however, because in fact it was not until 1638 that Braems acquired the site on which he built Bridge Place.[96]

No portraits of Braems or of his family, by Johnson or any other artist, are known to survive. An interesting later parallel to Johnson's possible experience, however, is that of the Dutch draughtsman Willem Schellinks (1623–1678), who, on a visit to England in 1661 (that is, after the Restoration), became the guest of Sir Arnold. The drawings that he made of Bridge Place and its grounds are now useful evidence as to its appearance (fig. 33).[97]

33
WILLEM SCHELLINKS
Sir Arnold Braems's house, 1661
Pencil and wash on paper,
171 × 282 mm
Rijksmuseum, Amsterdam

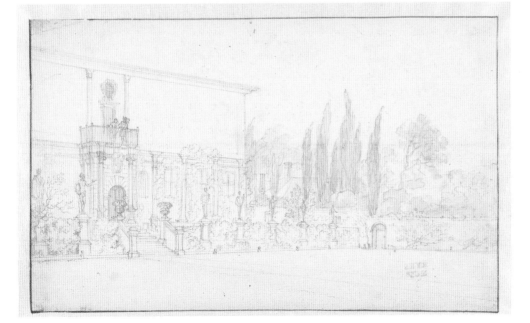

After Chilham Castle, Braems's country house was the largest in east Kent at the time; it was said to have been built with hand-made Dutch brick brought over from Holland and landed at Sandwich.[98] From Schellinks's account, it is clear that London was only a day away from Bridge – either by boat or road – and that this journey was one that was regularly undertaken. Schellinks described the deer park, aviary, bowling green, woods, rabbit warren and "beautifully well-kept pleasure gardens" of Bridge Place, which was "one hour's walk from Canterbury [3 miles]",[99] on the main road to Dover. He observed that because Braems was "so amiable and hospitable and keeps a princely board, he has an extraordinary number of visits from knights and high-born gentlemen and their ladies so that he is continually surrounded by his family and neighbouring friends at table".

Braems was born in 1602 in Dover, only twelve miles away from Bridge, to the wealthy merchant Charles Braems and his wife Josina Spike of London. According to Edward Hasted, the Kentish historian, his brother Jacob Braems built "the great house, now the custom house there" in Dover.[100] During the Civil War Arnold was a dedicated royalist, and when he died in 1681 he left an estate burdened with debt. Braems's second wife Elizabeth was a daughter of Sir Dudley Digges (1583–1639) of Chilham Castle, whose head-and-shoulders portraits Johnson painted in 1636,[101] when he became Master of the Rolls. In 1637 – the year after Walpole claims that Johnson first stayed at Bridge – Arnold was one of twelve defendants charged before the Star Chamber with illegally exporting gold; he was fined £2,000.[102] Later, in the years 1656 to 1658, during the Interregnum, Braems would journey regularly between England and Flanders as a royalist agent; at the Restoration, he was knighted by Charles II at Canterbury on 27 May 1660, on the way back to London.[103]

Inside St Peter's Church at Bridge, rebuilt in the mid nineteenth century, there are monuments to Braems's first wife Joan (died 26 July 1635 and buried in St Mary's, Dover) and to Elizabeth Digges, his second wife (who died 27 May 1643).[104] High on the east wall, in memory of Robert Bargrave (1584–1649), is a portrait.[105] John Newman, in the most recent edition of the Pevsner guide, describes it thus: "Very faded. Is it by Cornelius Johnson, who painted many of the local gentry?"[106]

In 1637 Johnson painted an unusual three-quarter-length portrait of an unidentified medical man (Royal College of Physicians). The physician is depicted as if seated in his library, among books labelled as the works of Hippocrates, Vesalius, Galen and Paracelsus; there is also a New Testament in Greek, which is open at a passage from the Book of Revelation. Various names have been proposed for this sitter – Jean Colladon (1608–1675), Dr Lewin Fludd (1612–1678) or Dr John Bathurst (1600–1675).[107] Such a particularized setting had previously been rare in Johnson's work, in which plain backgrounds,

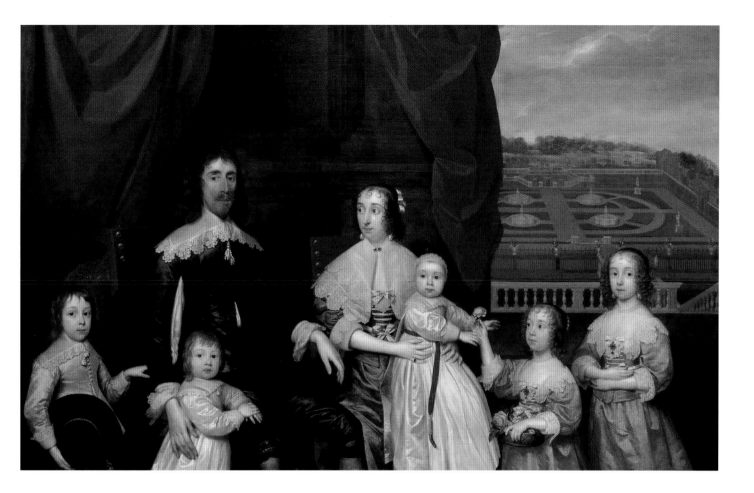

rapidly and economically painted, had predominated. For this portrait, Johnson adapted a composition that Daniel Mytens had used in about 1625 for the seated portrait of *Philip Herbert, later 4th Earl of Pembroke*.[108] Mytens in turn had adopted the composition (though not the method of handling paint) from van Dyck's portrait of *Thomas Howard, Earl of Arundel*, of 1620–21.[109]

Meanwhile, in London, in April 1638, an unnamed apprentice of the painter Rowland Buckett was turned over to Johnson by the London Painter-Stainers' Company.[110]

It was in around 1640 that Johnson was commissioned to paint the large group portrait of the 1st Baron Capel and his wife and their five surviving children (fig. 34). The painting celebrates the fecundity, health, good looks and elegant taste of the Capel family. The figures in it are heavily influenced by van Dyck's 'Greate Peece' of Charles I and his family, 1632 (see fig. 13).[111] Lord Capel was an enthusiastic royalist, and the adoption of such a model would be in line with his known devotion to his monarch. The garden behind is that of Hadham Hall, Herts, and its appearance here is more than just symbolic of the ideal of a well-regulated family standing for a well-regulated country. The broad accuracy of the depiction of the

34

CORNELIUS JOHNSON
The 1st Baron Capel and his family, c. 1640
Oil on canvas, 160 × 259.1 cm
National Portrait Gallery, London

CORNELIUS JOHNSON
Elizabeth Campion, 1631
Oil on panel, 76.5 × 61.6 cm
Private collection

garden has, interestingly, been confirmed by the survival of two other images of it during the seventeenth century.

Johnson's portrait miniatures

Alongside his large-scale works, Johnson also produced portrait miniatures. He worked in oil on metal (see fig. 30)[112] – a combination of medium and support used by no other identified miniaturists working in England, who instead used water-based media on vellum mounted on card (a technique that is often called 'limning').[113] This, again, suggests that Johnson learned the technique overseas. Johnson did not often sign these miniatures, but his handling of them is once again extremely characteristic. A few other extant seventeenth-century miniatures in oil paint on metal do depict sitters wearing English dress and were probably painted in Britain. Because little research has yet been carried out on English miniatures in oil paint on metal, these miniatures are often automatically attributed to Johnson, even when their handling and, indeed, their quality, does not warrant this. The refined miniature of Charles I mentioned earlier (page 22) – if it is indeed by Johnson – is in oil paint on silver, an appropriately luxurious support for a royal image.

Unfortunately, in many cases the sitters in Johnson's miniatures cannot now be identified. George Vertue suggested that Johnson copied these works from his larger-scale portraits, and noted "in small in a Case are the two heads of Sr. Robt. [Heath] and his lady", claiming that, "I have seen many of these small Oil Colour pictures instead of limnings said to be done by Corn Janson – these two are certainly coppyes from the larger ones. and very probably it might have been a custom much used with him to do both great and small."[114] One example of this process is a pair of images of the slave-trader Sir Nicholas Crispe, whose portrait at three-quarter-length, attired in a fine red and silver suit, with a landscape and military scene behind him, is now at Parham Park, Sussex , and whose related head-and-shoulders portrait miniature is in the Fondation Custodia, Paris. Another pair of related images by Johnson are in the collection at Powis Castle in Wales – a head-and-shoulders portrait of Richard Herbert, 2nd Lord Herbert of Chirbury in armour with an extensive lace collar, signed and dated 1635, and an extremely damaged oval miniature of the same sitter.[115] Although most of Johnson's miniatures are not signed, one example depicting an unknown man in a black jacket and white falling ruff is signed *CJ / 1628,*[116] while another of an unidentified elderly man is inscribed on the reverse *C. Johnson / Fecit 1639.*[117] When we do know who his sitters are, they are often members of the Netherlandish community in London, such as Dierick Hoste and his wife (fig. 30), and the couple's daughter and her husband, Peter Vandeput and Sarah Hoste (Thomson Collection, Art Gallery of Ontario).

36

CORNELIUS JOHNSON
Anne Uvedale, Mrs Henslowe, 1636
Oil on canvas, 77.7 × 64.7 cm
Verney collection, Claydon,
National Trust

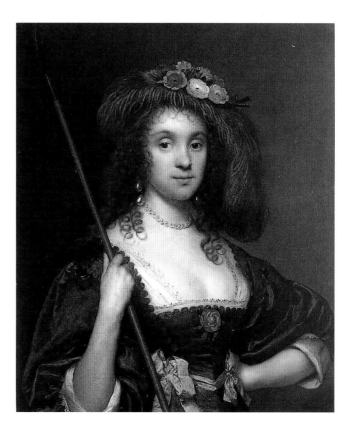

Johnson and dress

Johnson's work is particularly useful to historians of dress, because he tends not only to depict clothing in great detail, but also to date his portraits. Thus, from studying his portraits, it is possible to trace developments in fashion by date.[118] The wealthy Margaret Hungerford was depicted in 1631 wearing a bodice and skirt of red silk embroidered in gold and silver and with sparkling metal spangles, and a black over-gown tied with striped ribbon at the waist (fig. 12). Her paned and padded 'virago' sleeves (originally a French fashion) are also secured with striped ribbon. Wired up at the back, her extensive bobbin lace collar – a key signifier of style, wealth and status at this period – plays a considerable role in the effect of the portrait.[119] Johnson has depicted it with almost forensic attention to detail. This was clearly a presentation that rich upper middle class and gentry sitters like Margaret appreciated, and one that Johnson deliberately offered in his portraits of elite men, women and children.

Johnson has also minutely represented Margaret's valuable, though somewhat old-fashioned gold and diamond necklace, and the formal carcanet, or chain, also of diamonds set in gold, which rests across her breast and her shoulders. Fresh flowers worn in the hair contrast with the luxurious artifice of her attire – as they do in the portrait of *Elizabeth Campion* (fig. 35), whose green silk bodice

shimmers with silver spangles. Such a dialogue between nature and artifice was often a feature of British female portraits of the period.

In Britain during the 1630s, fashionable women's clothing became simpler in outline – either a bodice and skirt or a single all-in-one dress – and dense embroidery was abandoned for plain but luxurious and shiny satin, such as that seen in full length in Johnson's portrait of *Diana Cecil, Countess of Elgin*, of 1638 (fig. 25).

Johnson's portrait of *Anne Uvedale, Mrs Henslowe* – painted in 1636, the year of her marriage (fig. 36) – is unusual in representing her partly in 'pastoral' attire. A celebration of the pleasures of rustic life, in contrast to stressful court or city life, the idea of the pastoral, which originated in classical literature, became popular first in sixteenth-century Italian and then English literature. Pastoral became a central theme of early seventeenth-century masques – the costly entertainments which were performed by the elite at Court, wearing rich and complex costumes, that combined text, music, dance and elaborate sets. Portraits of sitters in pastoral dress – originally an Italian Renaissance invention – became common in the Netherlands, where pastoral plays became especially popular. Pastoral offered an imaginary world of ease and meditation, populated by shepherds and shepherdesses. In dress, it was signified by specific accessories, such as the shepherd's crook or *houlette*, and, for women, immense 'rustic' hats, garlands of fresh flowers and rolled-up sleeves. Van Dyck portrayed a number of his elite British sitters (both male and female) in pastoral attire, but it is rare in Johnson's oeuvre. Mrs Henslowe wears a fashionable dress in plain dark blue satin, adorned with plain yellow ribbons, but with a scalloped neckline which was associated with pastoral. She adopts a masculine, hand-on-hip posture, grasps a shepherdess's *houlette* and wears a very large hat with ostrich feathers and an arrangement of fresh flowers.[120]

The portrait of a lady who, according to information transcribed on the back of the canvas, is thought to be Dorothy Hammond, née Wilde (1590–1644), is another meticulous representation of fashionable dress (fig. 37, and see p. 6 for detail). Dorothy's father Thomas Wilde lived at St Martin's Hill, near Canterbury. By 1636, the date at which Johnson signed this beautiful portrait, Dorothy had been widowed for the second time, and was in her mid forties, so it is possible that the sitter may be another, younger, family member.[121]

Plain black was also a fashionable option at the time, worn with fine white linen, as seen in the portrait of *Margaret Nevinson*, 1636 (fig. 38). Her square kerchief is folded diagonally with a partlet and edging across the front of the bodice. She wears very fine knots at the ends of the band strings and corners of her kerchief. An *Unknown lady* (art market), also painted in 1636, wears exquisite linens worked in whitework and cutwork, and with a narrow edge of bobbin lace around the neck edge of the linens.[122]

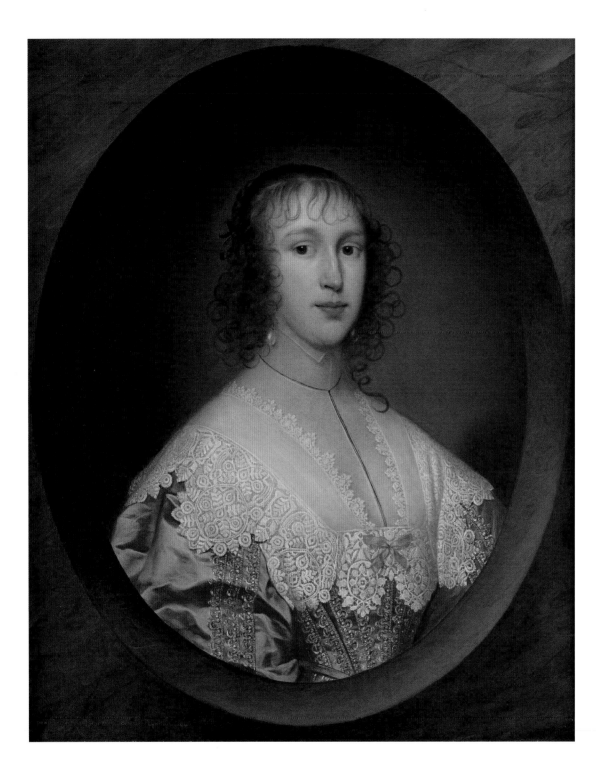

37

CORNELIUS JOHNSON
Dorothy Hammond, née Wilde (?),
1636
Oil on canvas, 79.5 × 65 cm
Frederick and Kathryn Uhde

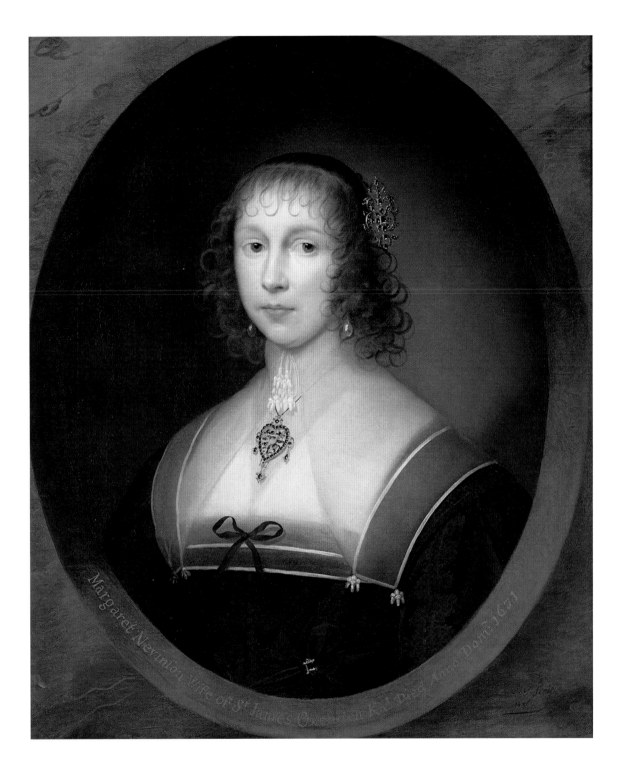

38

CORNELIUS JOHNSON
Margaret Nevinson, wife of
Sir James Oxinden, 1636
Oil on canvas, 76.8 × 61.6 cm
Private collection

39

The Johnsons' testimonial from
the Dutch church in London, 1643
Amsterdam City Archives, Archive
of the English Reformed Church,
no.318, inv. no. 118

40

CORNELIUS JOHNSON
Unknown young lady, 1646
Oil on canvas, 79.4 × 64.1 cm
Tate

After Johnson's migration to the United Provinces in 1643, his sitters' attire exemplified Dutch bourgeois style – plain but costly black fabrics with discreet white lace and lawn collars and cuffs. Large pieces of jewellery stood out prominently against the black (see fig. 40). By the 1650s, and Johnson's Utrecht period, Dutch fashions were changing. Some women adopted plain satin dresses in lighter, brighter colours, which Johnson seems sometimes to have depicted in a simplified form. A curious fashion for wearing a single large patch, or 'beauty spot', at the left temple arose and was sometimes shown in portraits (see fig. 50).[123]

Civil war and Johnson's departure for the Netherlands

In 1641 van Dyck died. This should have re-opened opportunities for the artists in London whom he had pushed aside. However, the political situation in Britain was deteriorating, and the king and Court left London in 1642. In October 1643, according to George Vertue, Johnson, "being terrifyd with those apprehensions & the constant perswasions of his wife", emigrated with his family to the Netherlands.[124] His pass "is recorded in the journals of the House of Commons dated 10 October 1643" thus: "Cornelius Johnson, Picture Drawer, shall have Mr Speaker's Warrant to pass beyond the seas with Emmanuel Pass and George Hawkins and to carry with him such pictures and colours, bedding, household stuff, pewter and brass as belonged to himself".[125] On 23 October, the Dutch church in London provided a testimonial (or "attestation") that the Johnsons would be able to present at any other Dutch-speaking reformed church (fig. 39).[126] On 27 October (according to Vertue) they "left London & went to Middelbourg".[127]

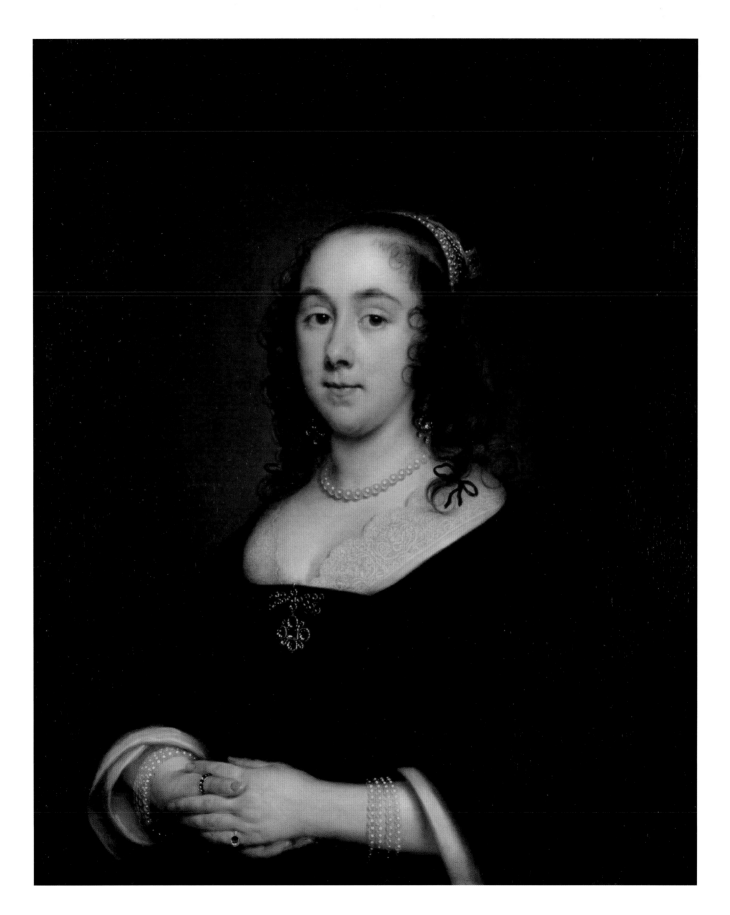

CORNELIUS JOHNSON
Apolonius Veth, 1644
Oil on canvas, 78.1 × 63.5 cm
Tate

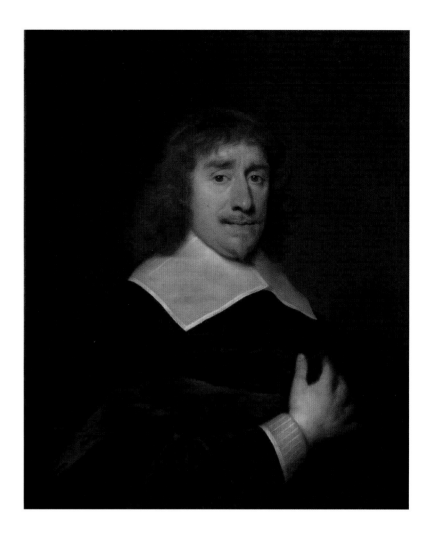

Together with Leiden and Haarlem, Middelburg was the city in the United Provinces that had most benefitted from the emigration of Reformed Protestant merchants and craftsmen from Antwerp and other centres in the southern Netherlands.[128] There Johnson joined the painters' guild, the Guild of St Luke, during the account-book period that ran from 23 December 1642 to 8 January 1644 (Dutch style). (The dating system on the Continent was ten days later than in England – meaning that 8 January 1644 there would have been 29 December 1643 back in England.)[129] This indicates that Johnson intended to set up in practice there. His individual portraits now fused van Dyckian compositions with the more serious spirit of his Dutch sitters' expectations.

On 2 March 1644 (Dutch style) the records of the English Church at Middelburg state that "as passengers [visitors] were admitted M[r] Cornelis Johnson, his wife and maid servant called ... Bristow upon the view of Attestation from the dutch church at London".[130] During 1644, Johnson signed and dated the companion half-length portraits of *Apolonius Veth* (1603–1653; fig. 41) and his wife *Cornelia Remoens* (both Tate). This must have been a prestigious commission

for Johnson, for in 1644 Veth was the burgomaster of Middelburg; indeed, Veth also held this office in the years 1632, 1635, 1638, 1641 and 1647.

Why had the Johnsons chosen to settle in Middelburg? At this date, it was, after Amsterdam, the leading trading centre in the United Provinces. Moreover, the Johnsons had relatives and friends there. Dierick Hoste had originated in Middelburg, where he retained property and was a regular visitor; indeed, he too travelled there in 1643.[131] The pastor of the Dutch church in London, Willem Thielen, and his wife Maria and family had returned there after leaving London. Although Willem had died in 1640, Maria was still resident there. Indeed, Johnson was to produce a portrait of one of the couple's sons, *Willem Thielen junior*, at the age of nine in 1643. It is in his old feigned oval format – the one that he had used for his portraits of the boy's parents, painted back in London in 1634. It seems likely that the widowed Maria specifically asked him to do this so that the portraits would all match.[132]

Amsterdam

On Sunday 27 August 1645 Johnson and his wife attended the English church in Amsterdam for the first time, appearing in the list of "strangers admitted to the sacrament" for that day. Having presented their certificate of membership, or attestation (in Dutch), from the Dutch church in London, they seem to have become official members and to have attended regularly.[133] It is not clear where Johnson lived in Amsterdam, but in 1646 he signed and dated portraits of a number of Amsterdam citizens.

At this stage, moreover, Johnson again began to vary the form of signature that he applied to his paintings. In 1646 he painted a half-length portrait of *Jan Cornelisz Geelvinck* (1579–1651), a merchant, ship-owner and political figure, who, in the same year, was appointed burgomaster of Amsterdam for the eleventh time (Amsterdam Museum).[134] In signing this portrait, Johnson used the wording *Cor^{ns} Jonson. / Londin^{es} fecit / 1646*. He was thus now marketing himself as a painter from London. The following year, having been commissioned to paint an immense civic group portrait, of *The Hague Magistrates,* he chose to sign it *Cornelius Jonson Londini fecit, / Anno 1647* (fig. 42).[135]

In the Netherlands Johnson clearly remained popular with British clients. In 1649 he signed and dated a double portrait of two exiled Scots, *William, Earl of Lanark and 2nd Duke of Hamilton, and John Maitland, later Duke of Lauderdale*. Two versions of this portrait survive, one at Ham House (which was later the residence of Lauderdale; fig. 43) and the other still with the Hamilton family. The two noblemen were Covenanters; they had attempted to advise, and had negotiated with, Charles I, and had coordinated and signed the so-called 'engagement' or three-kingdom strategy. At the

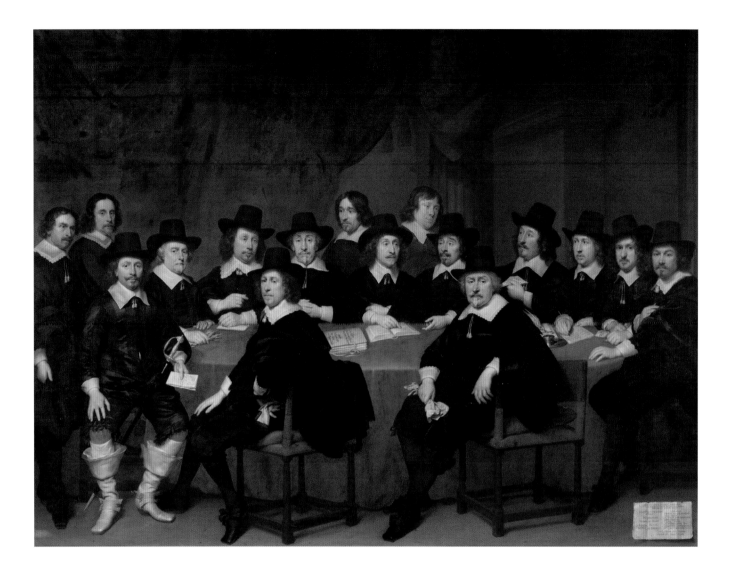

42

CORNELIUS JOHNSON
The Hague Magistrates, 1647
Oil on canvas, 285 × 375 cm
Haags Historisch Museum,
The Hague (on display in the
Old City Hall)

end of January 1649, following the execution of Charles I, the two men escaped to join Charles II in the Netherlands. In The Hague, they urged the exiled new young king to comply with the kirk party, to return to Scotland and to take the covenant. Evidently, they also marked their alliance by commissioning their joint portrait from Johnson. Charles's acquiescence was sealed by the Treaty of Breda, and in June 1650 Hamilton and Lauderdale returned with Charles to Scotland. Double portraits of this kind, depicting a pair of friends or associates, had been a speciality of Van Dyck's, and was a format that he had effectively introduced to British art.[136]

In 1649, "Cornelis Ianssens Schilder tot Amsterdam" was among the artists included in *Images de divers homes d'esprit sublime …* by the Antwerp printer Jan Meyssens (1612–1670). In the print by Coenraet Waumans after a (now lost) half-length seated self-portrait (fig. 1), Johnson, plumply attired in a flowing black satin mantle, turns elegantly to face the viewer, a palette and three paint-brushes on

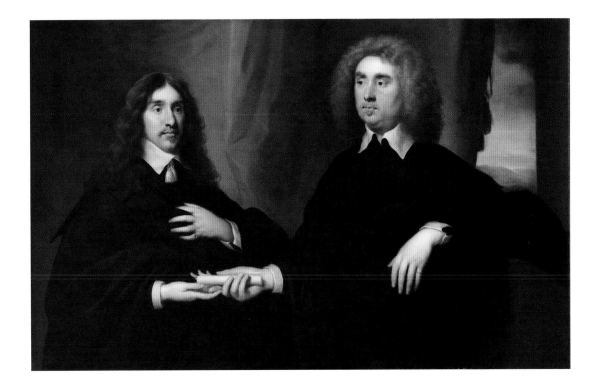

the table upon which he leans.[137] The caption, in French, describes him as *Paintre tres excellent en grandes, et petites ordonances: mais une Lustre de portraicts avecq un admirable entendement. La ville d'Amstelredam at le bonheur de iouir de sa persone, il a demeure long temps en Angleterre, ou il a faict plusieurs belles et admirables pieces, pour le Roij et plusieurs autres grandes Seigneurs.*

At around this time, Johnson and his wife returned to Middelburg, where on 30 June 1649 they re-joined the congregation of the English church there, with a testimonial from the English church in Amsterdam. On 24 October 1649, "Cornelis Janson [sic]" was proposed as an Elder of the church, and on 10 November "M.r Cornelis Johnson" was voted in as an Elder. In the church's subsequent records his name is consistently spelt 'Johnson'.

In 1650, he painted another large civic portrait – of *The Middelburg Archers' Guild* (fig. 44).[138] It is a surprisingly old-fashioned composition for 1650, perhaps at the request of the guild. His old client Apolonius Veth was Deacon of the guild that year, and among the twenty figures depicted Veth is seated in a dominant position.

As Elder of the English church in Middelburg, "Mr Johnson" was again mentioned in the church's records in January 1650. He appears to have been present at all its meetings that year, except those on 27 July, 14 September and 30 November 1650, when he is noted as being absent. On 29 October 1651, there were fresh elections for church Elders. Johnson was one of two Elders who had served a mere two years, and it was agreed that one of them

43

CORNELIUS JOHNSON
William, Earl of Lanark and 2nd Duke of Hamilton, and John Maitland, later Duke of Lauderdale, 1649
Oil on canvas, 149 × 199 cm
Ham House, National Trust

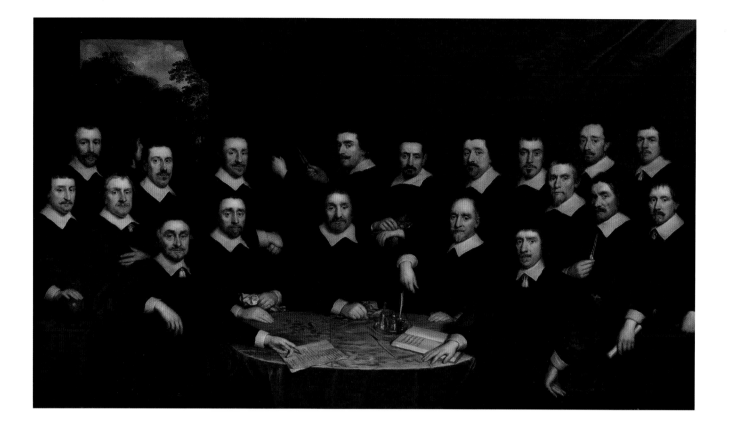

44

CORNELIUS JOHNSON
The Middelburg Archers' Guild, 1650
Oil on canvas, 198 × 340 cm
Old City Hall, Middelburg

could continue. The choice was made 'by lot' and Johnson, as the unsuccessful one, stood down, therefore, on 21 November 1651.

Utrecht

During 1652 Johnson and his wife moved to Utrecht – a substantial distance from Middelburg, although closer to Amsterdam. On 7 November that year they signed a document ("*voogdijstelling*") in which, now living in the Herenstraat in Utrecht ("*inde Heerenstraet*") – a high-status address – they appointed each other guardian of their underage children and/or grandchildren. This was a customary provision by wealthy citizens of Utrecht to prevent the city's administrators taking over the orphans' estate. The notary, Johan van Steenre, was a brother-in-law of the painter Cornelis van Poelenburch (1594–1667); while the witness, the notary's son Wouter, would probably already have been a pupil in his uncle's studio.[139] Van Poelenburch, best known as a painter of small pastoral paintings featuring little figures in idealized landscapes, must have known Johnson from his days in London, as he had worked there for Charles I between 1637 and 1641. A surviving portrait drawing by Johnson, annotated as being of *Joffrou Poelenburg* (fig. 50), indicates further links with the family.

In 1652 the Dutch and English went to war, making 'Londini' no

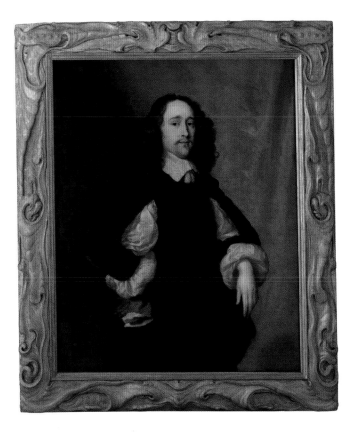 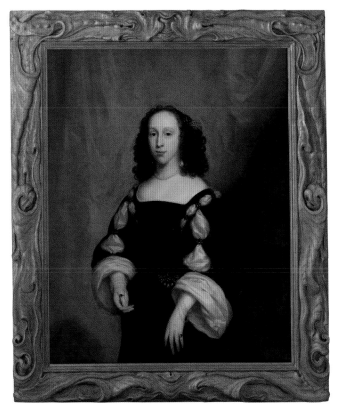

longer such a good marketing idea. Now he began to sign his works
'Cornelius Jonson van Ceulen' [that is, 'of Cologne'] – a wording
that asserted another form of 'foreignness' as his selling-point.
This seems to have been the wording that he finally settled on,
consistently using it during the last decade of his painting life.

Johnson received commissions from members of the Utrecht
elite families and was evidently accepted as a leading portrait
painter. His portrait of *Adriaan van Blijenburgh* (1616–1682), from
Dordt, but with Utrecht relatives, is dated 1654 (private collection).
In the same year he also painted companion portraits of the
Utrecht patrician Jasper Schade (1623–1692) and his wife Cornelia
Strick van Linschoten (1628–1703; figs. 45 and 46); the couple had
married in 1649.[140] Cornelia's portrait is an example of Johnson's
use at this period of a form of simplified, or 'timeless', dress for his
female sitters – a concept that had been introduced by van Dyck in
London back in the 1630s to counter the inevitable outdatedness
that precisely fashionable depiction would eventually suffer.[141]

Once again, Johnson seems to have offered a limited range
of poses, with the result that similar compositions, with subtle
differentiations, recur among his portraits of both male and female
sitters, often now depicted against blue or green backgrounds.

On 19 June 1655 "Cornelius Jonson van Ceulen, the skilful
painter" gave power of attorney to his cousin ("*neef*") "*S͏ʳ. Hansch*

45

CORNELIUS JOHNSON
Jasper Schade, 1654
Oil on canvas, 113.5 × 91 cm
Rijksmuseum Twenthe,
Enschede

46

CORNELIUS JOHNSON
*Cornelia Strick van
Linschoten*, 1654
Oil on canvas, 113 × 90.8 cm
Rijksmuseum Twenthe,
Enschede

Hoste … koopman [merchant] *te Middelburg*" in a specific legal case, indicating his continuing strong ties with his Hoste relatives in Middelburg.[142]

Johnson's name appears frequently in the records of the English church in Utrecht, St Mary's (the Maria Kirke). As in Middelburg, he clearly again held an office within it, as it was noted in the minutes that he had sent letters stating that he would be absent from meetings on 4 February and 9 April 1658.[143] On 5 April 1658, he and another Elder "hauing serued their time, desired the brethren to chuse other able men in their places. The brethren wishing to enjoy their company longer were sorrowfull to understand it, but … could not deny it unto them."[144]

In Utrecht he was visited by the former Fellow of St Peter's College, Cambridge, John Bargrave (1610–1680), whose kinsman, Dean Isaac Bargrave of Canterbury, Johnson had depicted during the 1640s, and who showed him an optical effect using "a common prism or triangular artificial crystal". Offering a rare insight into Johnson's personality, Bargrave, who had known him back in England, recounted:

> at Utrecht … there lived one MynHere Johnson, an extraordinary eminent painter, of my former acquaintance in England. I showed him this artificial rainbow; he asked me how long I could keep it; I told him that I could keep it 2 or 3 hours: 'Then,' saith he, 'I will send for my pallat of coulors, and draw it, for I have binn after endeavouring to draw one in the fields, but it vanished before I could finish it.' Upon which I laughed. He asked me why I laughed; I told him that he should see anon why I laughed, but assured him that I could keep the rainbow 2 or 3 hours; upon which he sent a servant for his pallat of colours, and, being come, he tempered them to his purpose in the light. Then I darkened the room, but he could not see to paint, at which I laughed again, and I told him his error, which was, that he could not see to paint in the dark, and that I could not keep the rainbow in the light, at which he laughed also heartily, and he missed his design.[145]

The young Willem III of Orange-Nassau (1650–1702) was the posthumous son of Willem II and Charles I's daughter Mary (1631–1660), whom Johnson had painted as a little girl in 1639 (fig. 19). Willem, whose political position in the Republican Netherlands was insecure, was frequently portrayed as a child, including in a rather van Dyckian full-length by Adriaan Hanneman in 1654.[146] In 1657, Johnson was commissioned to paint him, at the age of seven. There are a number of versions of this image, of different sizes and varying quality. One of the best is the example at Knole, in Kent, which is signed and dated in red paint, *Cornelius Jonson / van Ceulen. / fecit. / 1657* (fig. 47).[147] Others

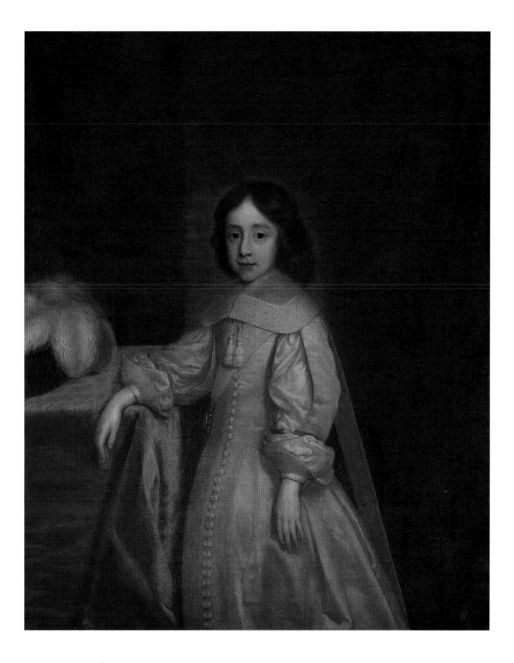

(in which Willem's face looks a little older) are clearly by the members of Johnson's Utrecht studio – among whom must have been his son Cornelius. Indeed, a head-and-shoulders version at Eastnor Castle is actually signed by him, lower right, *C.J: Van Ceulen, Junior / Fecit 1658*.

In 1657, too, Johnson painted a grisaille portrait, in a feigned oval, of the learned Utrecht gentlewoman Anna Maria van Schurman (1607–1678) (National Gallery of Art, Washington). A unique survival in Johnson's oeuvre, this grisaille was evidently intended to be the model for a print, and indeed was engraved by Cornelis van Dalen the Younger (1638–1659/64); the third state of it incorporates a verse by Constantijn Huygens.[148] Anna Maria had

47
CORNELIUS JOHNSON
Willem III of Orange-Nassau as a boy, 1657
Oil on canvas, 109 × 86.4 cm
The Sackville collection, Knole

been born in Cologne to a Protestant family that had subsequently migrated to the Northern Netherlands. She had taken lessons in drawing and painting – and was made an honorary member of the artists' guild in Utrecht in 1643 – but was principally known for her intellectual achievements. She was the first woman to study at a university in the Netherlands, and the fame of her piety, and her knowledge of languages, history, poetry, the liberal arts, philosophy, medicine and theology, were spread through Jacob Cats's praise of her in his *'s Werelts begin, midden, en eynde besloten in den trou-ringh, met den proef-steen van den selven* (Dordrecht, 1637). Subsequently, she would be much visited by foreign scholars and nobility.

The minutes of the Utrecht English church for 3 June 1660 included a reference to "Mr Tuer".[149] This is Herbert Tuer, an English-born painter, who would later witness Johnson's wife Elizabeth's testamentary document. It seems likely that he too worked in Johnson's studio.[150] According to Horace Walpole, Tuer's mother Catherine was a niece of the poet George Herbert (whose surname he bore as his first name). After the execution of Charles I in 1649, he and his youngest brother, Theophilus, "withdrew into Holland". While his brother became a soldier, Herbert "applied to painting, and made good progress in portraits, as appears by some small ones of himself and family, now in England, where, however, they are little known …. It is believed that he died at Utrecht."[151]

In a document dated 8 December 1660, Cornelius Jonson van Ceulen "*constschilder*" (fine art painter) authorized the painter Dirck van Delen, the mayor of Arnemuiden in Zeeland, to act for him in relation to a financial claim.[152] Meanwhile, a number of three-quarter-length portraits dated 1660 by Johnson survive, including a fine one of an unidentified woman, in crisply painted light-coloured silks, now in Washington.[153]

On 3 June 1661, according to the English church's minutes, "Mr Johnson van Ceulen was deputed to appear to morrow in the classes [regional council] with Mr: Best [the minister] and according to order letter of credence was given them".[154] This suggests that Johnson was still an active man. However, a mere eight weeks or so later, on 5 August 1661, he had died and was being buried, in the Regulierskerk in Utrecht (because the English church there had no burial facilities.) Twelve people carried his coffin, an indication of his high status.[155]

A fortnight later, his widow, "Elisabeth Beeck", and her son "Cornelis [sic] Jonson van Ceulen … aged over 25 years", renewed Johnson's financial authorization to Dirck van Delen. The document was drawn up in their house in the Herenstraat in Utrecht, and, as mentioned earlier, one of the two witnesses was Herbert Tuer.[156] It appears that Johnson's wife Elizabeth may subsequently have returned to Amsterdam in 1661.[157] She was, however, buried in Utrecht on 30 November 1663, also in the Regulierskerk. There were twelve coffin-bearers, and a fine was paid for it being late in the day –

a further sign of status.[158] During 1662 Cornelis de Bie republished, in *Het Gulden Cabinet*, the portrait engraving of Johnson that had first appeared in 1649, along with a 24-line verse in Dutch praising Johnson and describing him as an Amsterdam painter.

Johnson's techniques

Johnson's profile in the London artists' community is indicated by the appearance of his name in the manuscript of Dr Theodore Turquet de Mayerne, the Swiss-born physician to James I and to Charles I's court. De Mayerne was fascinated by the practicalities of painters' techniques. He questioned many of the leading artists whom he encountered in London and, beginning in 1620, collected his findings in a manuscript entitled '*Pictoria Sculptoria et quae subalternarum artium*'.[159] He annotated one page in this "*M^r Janson bon Peintre*" – that is, "Mr Johnson – a good painter" (fig. 48). In his manuscript, De Mayerne wrote his own notes in French, but he transcribed the recipes themselves in various languages – presumably depending on the one spoken by the artist from whom he acquired it. Johnson's recipe appears in English and is an account of the properties of the yellow pigment orpiment. The page is, in fact, in a distinctive script, perhaps Johnson's own, although it differs from the script that he used for the monograms and signatures that he painted on his portraits. Orpiment is a poisonous pigment, and very difficult to use, as it is incompatible with certain metal-based pigments, but it can be an option for a painter who wishes to depict gold jewellery. Johnson's recipe advises using yellow ochre, or English ochre, as a ground for the orpiment, which should be used only for "Hightnings".

Technical advice from Johnson also appears in an English manuscript of the 1650s compiled by a minor graphic artist called Daniel King.[160] It includes paint mixtures that had supposedly been used by van Dyck, which had perhaps been passed on by someone who had worked in his studio. The manuscript also includes two pieces on Johnson's methods of painting draperies. For linen draperies "white and oker a little broken with bone blacke" is recommended. For blue draperies, Johnson first laid in "all the folds and shadowes ... neatly and perfectly finished" with "indico ground in drying oyle and mixt w[i]th smalt and white". When this had dried, he painted over it a glaze of ultramarine and "fair white". This would be a practical and economical method of achieving an effective blue – using the cheaper blue pigments, but topping them with a small amount of the costly ultramarine. Examination by Arabella Davies of two portraits of 1644 by Johnson in the Tate collection, of the Middelburg burgomaster Apolonius Veth (fig. 41) and his wife Cornelia Remoens, confirmed that the lace and linen worn by the couple contain ultramarine and smalt. A considerable amount of yellow ochre was also found in the imprimatura layer.[161]

48
Johnson's advice on the use of orpiment in Dr Theodore Turquet de Mayerne, '*Pictoria Sculptoria et quae subalternarum artium*', 1620 onwards
Sloane MS 2052, fol. 152r
British Library, London

CORNELIUS JOHNSON
Sketch of a woman's hands,
late 1640s?,
Black and white chalk on
blue paper, 191 × 295 mm
J. Paul Getty Museum,
Los Angeles

Johnson's drawings

Very few drawings by sixteenth- and early seventeenth-century British artists – whether they had been born and trained overseas or in Britain – have survived. Once again, Johnson differs from his compatriots, in that a handful of his preparatory sketches are extant. All, save perhaps one, seem to have been made towards painted portraits, and all appear to date from after his emigration to the United Provinces in 1643. George Vertue noted that he had acquired from Johnson's great-nephew "three or four leaves of a pockett book formerly belonging to Cornelius Jansen. Painter. With writing of persons Names. & some Sketches."[162]

Anthony van Dyck made preparatory sketches as part of his portrait production process. The banker and collector Everhard Jabach (1618–1695) described the experience of being painted by him in London. Van Dyck would make a compositional drawing of the sitter's figure and clothing from life, in chalks on coloured paper, which he would then pass to his assistants, who would enlarge and paint it on to the canvas. Another sitter, the English painter Richard Gibson (1615–1690) remembered how "Vandyke [sic] would take a little piece of blue paper upon a board before him & look upon the Life & draw his figures & postures all in Suden lines, as angles with black Chalk, & heighten with white chalk".[163] A number of these rapid sketches by van Dyck survive.[164]

Given that no very early drawings by Johnson are known, it seems plausible that he may have noted how they were part of the practice

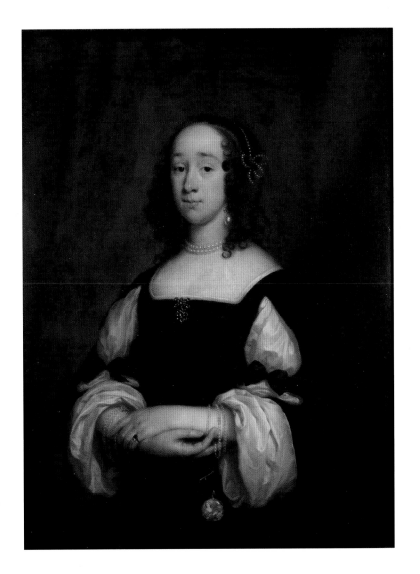

50

CORNELIUS JOHNSON
Unknown lady, 1650
Oil on canvas, 108 × 80.2 cm
Centraal Museum, Utrecht

in the studio of his Blackfriars neighbour. A detailed sketch of a
woman's folded hands, in black and white chalks on blue paper,
which is annotated *jefrow Raphune* in brown ink across the bottom,
was clearly made towards one of Johnson's Dutch-period female
portraits (fig. 49).[165] Pinholes along the outer edges of this drawing
suggest that Johnson attached the sheet of paper to a board, or an
easel, and then drew the sitter's hands from life. The disposition
of her hands is very close to that seen in his portrait of an *Unknown
young lady* (Musées Royaux des Beaux-Arts, Brussels), dated 1646,
but it is also similar to that seen in another 1646 portrait of a young
lady, presumably from an elite Amsterdam family (fig. 40).

A fully worked-up three-quarter-length chalk drawing by
Johnson, of a young woman holding a watch (Leiden University),[166]
resembles a painted portrait, signed and dated 1650, of an
unknown lady whose watch bears an image of Judith with the
head of Holofernes (fig. 50).[167]

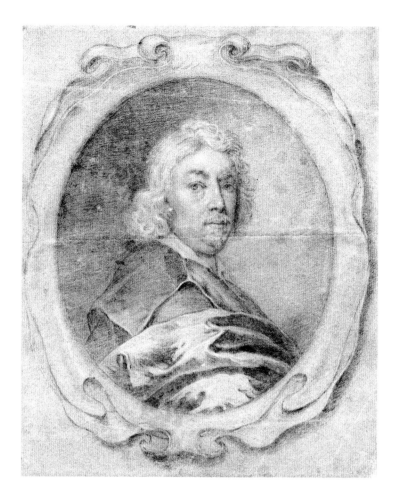

51

CORNELIUS JOHNSON
Self-portrait, early 1650s?
Black chalk heightened with
white on grey-blue paper,
271 × 221 mm
British Museum, London

Another drawing in black and white chalks on blue paper,
in the British Museum, has been said to be a self-portrait by
Johnson (fig. 51). Comparison of the facial features with Johnson's
as depicted by Adriaan Hanneman in about 1637 suggests that
this is probably correct.[168] The posture is convincing as that of an
artist gazing at himself in a mirror, while the attire – a satin gown
with large sleeve openings – appears to date from Johnson's Dutch
period; his face looks distinctly middle-aged.

Finally, a large fully finished portrait drawing of the head of an
unidentified woman, dating from about 1650, now in Berlin, seems
to be unique in Johnson's surviving oeuvre (fig. 52). Little seems
to be known of its history, but its early annotation, bottom right,
het portret van Joffrou Poelenburg / door Janz van Ceulen, suggests
that the sitter was related to Johnson's Utrecht painter colleague,
Cornelis van Poelenburch.

52

CORNELIUS JOHNSON
Unknown lady (*Joffrou
Poelenburgh?*), c.1650
Black and white chalks on
blue paper, 404 × 281 mm
Kupferstichkabinett,
Staatliche Museen zu Berlin

Johnson's market strategies

Initially, Johnson had to construct a career as a second-generation
immigrant in Britain, which at this period could not, it seems,
provide a formalized training for a painter. Nevertheless, he
found himself a sound technical training, which included the
judicious use of materials, apparently at least partly in the northern
Netherlands. He offered portraits on every scale, including what
seems to have been a rare specialism, oil miniatures. He was
perpetually tweaking the manner in which he presented his sitters
– often responding to the innovations made by his contemporaries
– yet his work always remains recognizably individual. He charged
modest prices, and was prepared to collaborate with other
artists – including Mytens, Houckgeest and van Steenwijck –
and to make modified copies of others' works, including those
of his famous Flemish neighbour in London, van Dyck. He used

a carefully chosen, limited range of poses. He seems to have been the painter of choice for many leading lawyers and public servants, and, perhaps as a resourceful response to van Dyck's metropolitan success, he also developed a regional clientele away from the court, in the south-east of England, primarily in Kent. He thus turned out to be adept at responding to external influences and changes, including some major setbacks.

Clearly a pragmatist, Johnson constantly demonstrated an awareness of the need to be flexible. Ultimately, this included the hard-headed decision to leave the country into which his family had largely assimilated and to migrate again, this time to the United Provinces. There, his changes of signature signalled the re-invention of his artistic national identity as a marketing tool in the various Dutch cities in which he worked – sometimes using van Dyckian compositions that he would have seen in London (fig. 53).

As research for this book has revealed, Johnson also depended on the networks associated with the various Reformed churches that he attended – initially that at Austin Friars in London, and subsequently those in Middelburg and Amsterdam, as well as in Utrecht, where, presumably as a result of his professional flexibility and pragmatism, he was a prosperous man at his death in 1661.

It was a lifetime trajectory eloquently described by Joachim von Sandrart. Johnson's parents, he wrote, had "moved to London as a result of the conflict in the Spanish Low Countries He produced elegant images of the King, the Queen and the whole court. However, when the dispute which arose between King and Parliament had extended to involve the whole of England, Johnson, together with nearly all the most famous artists, left England, moving to Holland, and ... there he produced many excellent portraits."[169]

53

Clockwise from top left: signatures from *Unknown lady* (1619; fig. 3), *Dorothy Hammond* (?) (1636; fig. 37), *The Hague Magistrates* (1647; fig. 42) and *Willem III of Orange-Nassau* (1657; fig. 47)

Notes

1 Portraits of *Willem Thielen* and his wife *Maria de Fraeye*, dated 1634 (Catharijneconvent, Utrecht); see Ruud Priem, 'Een "begaaft en seer ijverich man": Willem Thielen en zijn echtgenote Maria de Fraeye, geportretteerd door Cornelis Jonson van Ceulen', in *Face Book: Studies on Dutch & Flemish Portraiture of the 16th–18th Centuries*, Leiden 2012, pp. 215–26.

2 A few earlier historians of British art took an interest in Johnson: see Charles Henry Collins Baker, *Lely and the Stuart Portrait Painters*, I, London 1912, pp.74–86,, and II, pp. 113–15 (an important book and a remarkable achievement for its date, which even now remains a useful starting-point for studying individual seventeenth-century British artists); and Alexander Joseph Finberg, 'A Chronological List of Portraits by Cornelius Johnson', *Walpole Society*, X (1922), pp. 1–37 (a preliminary account of Johnson's oeuvre, which Finberg had largely assembled prior to World War I). There has been no subsequent study devoted to the full range of Johnson's work, although between the 1940s and the 1970s Sir Oliver Millar published a number of discoveries concerning his paintings, including 'An Attribution to Cornelius Johnson Reinstated', *Burlington Magazine*, XC (1948), p. 322; Margaret Whinney and Oliver Millar, *English Art 1625–1714,* Oxford 1957, pp. 60–61, 64–67; Oliver Millar, *The Tudor, Stuart and Early Georgian Pictures in the Collection of Her Majesty The Queen,* London 1963, p. 90; *The Age of Charles I*, exh. cat., Tate Gallery, London 1972, pp. 30–35. Rudi Ekkart wrote the entry 'Jonson [Janson; Johnson] van Ceulen, Cornelis [Cornelius]', in Jane Shoaf Turner (ed.), *The Dictionary of Art*, 1996, XVII, pp. 644–66. The present author published an essay, 'The English career of Cornelius Johnson', in Juliette Röding et al. (eds.), *Dutch and Flemish Artists in Britain 1550–1800*, Leiden 2003 (Leids Kunsthistorisch Jaarboek, no. 13), pp. 113–29, and a new *Oxford Dictionary of National Biography* [*ODNB*] entry on him in 2004. *Face Book* 2012 (see note 1 above) – a collection of papers published in honour of Prof. Rudi Ekkart – included three essays on individual portraits by Johnson. Dutch accounts of Johnson's career include Cornelis de Bie, *Het Gulden Cabinet*, Antwerp, 1662, pp. 298–29 (as 'Cornelis Ianssens'); Arnold Houbraken, *De Groote Schouburgh de Nederlantsche Konstschilders en Schilderessen*, The Hague, 1753, II, pp. 224–25 (as 'Janson van Keulen'); Jacob Campo Weyerman, *De Levens-beschryvingen der Nederlandsche Konst-Schilders en Konst-Schilderessen*, The Hague 1929, III, pp. 272–74 (as 'Janszon van Keulen'); and Johan van Gool, *De Nieuwe Schouberg der Nederlantsche Kunstschilders en schilderessen*, The Hague, 1751, I, pp. 22–24 (as 'Jansons van Keulen').

3 London Metropolitan Archives CLC/180/MS07381 Dutch Church 'Register of Baptisms and Marriages 1570–1601', recorded on 14 October 1593: "*gedoopt Cornelis fil*ᵘ. *Cornelis Jansz*" (Cornelius, the son of Cornelius Janson, was baptized).

4 Mary Edmond, 'Limners and Picturemakers: New Light on the Lives of Miniaturists and Large-scale Portrait Painters Working in London in the Sixteenth and Seventeenth Centuries', *Walpole Society*, XLVII (1978–80), pp. 60–242.

5 See Frederik Daniel Otto Obreen, *Archief voor Nederlandsche Kunstgeschiedenis*, VI, Rotterdam (1884–87) p. 171: 'Het Boeck van Sint Lucasgilde. Begonnen Ao. 1642 1/23' "*Ontfangen CORNELIS JANSEN, fijnschilder, voor sijn incomen 2) L1-6-8*". The original document apparently no longer survives.

6 Edmond 1978–80, p.89.

7 For example A. Bredius, *Kunstler-Inventare*, IV, The Hague 1917, pp. 1302–03, records that on 5 April 1678, "*Cornelis Jansz van Ceulen* [junior], *schilder woonachtig tot Utrecht, tegenwoordigh hier ter stede* (in Amsterdam)" pledged some paintings by various artists against a loan from Hendrick Uijlenbroek [sic] de Jonge; for the date of his burial, 20 December 1715, see Walter Liedtke, *Dutch Paintings in The Metropolitan Museum of Art*, New Haven and London, 2007, I, cat. no. 95, p. 384. Dr Marten Jan Bok has kindly passed on a number of additional archival references to Cornelius Johnson the Younger.

8 Joachim von Sandrart, *Academia Nobilissimae Artis Pictoriae*, I, Nuremberg 1683, p. 314. The following translation of it was kindly supplied by Dr Keith Cunliffe: "Cornelis Jansonius can be considered a Londoner of Flemish extraction because his parents were born in the Spanish part of the Low Countries, and emigrated to London on account of the war upheavals, where they produced this child. He, applying himself to the art of painting, devoted himself to the art of portraiture in particular. As a result, he was taken into the service of Charles Stuart, king of England, and produced elegant images of the king and the queen and of the whole Court. However, when civil dissent between the king and Parliament had disturbed everything, Johnson, along with almost all the artists of any note, left England and took up residence in Holland, which was then enjoying happiness and prosperity; and there, after he had produced many excellent portraits, he departed from this vale of suffering in the year 1665 in Amsterdam."

9 Bainbrigg Buckeridge, 'An Essay Towards an English School', in Roger de Piles, *The Art of Painting, and the Lives of the Painters*, London 1706, 3rd edn, 1754, p. 391. Horace Walpole, in 1762, stated that "Jansen … inaccurately called Johnson" had been born in Amsterdam. According to Walpole, his portraits were "easily distinguished by their clearness, neatness and smoothness. They are generally painted on board, and except being a little stiff, are often strongly marked with a fair character of nature, and remarkable for a lively tranquility in the countenances."

10 Sidney Lee (ed.), *Dictionary of National Biography*, X, London 1908, pp. 685–86; superseded by Karen Hearn's entry on 'Cornelius Johnson' in the *ODNB*, XXX, Oxford, 2004, pp. 243–44.

11 www.bbc.co.uk/arts/yourpaintings/cornelis-janssens-van-ceulen.

12 College of Arms, London, MS C24 fol. 608. Unlike some transcripts of original visitation pedigrees, this one does not bear the signature of the householder (that is, Johnson) himself. I am grateful to Timothy Duke, Norroy and Ulster King at Arms, for advice on this, and for enabling me to examine the pedigree. See also Joseph Jackson Howard (ed.), *The Visitation of London AD 1633, 1634 and 1635*, Part 2, Harleian Society, 17, London 1883, p. 15; the Johnson family arms were subsequently discussed in Lionel Cust, 'Notes on Various Works of Art: Cornelius Janssen van Ceulen', *Burlington Magazine*, XVI (1909–10), pp. 280–81.

13 I am grateful to Dr Manfred Huiskes, in Cologne, for checking for references to the Johnson family and to their arms in the resources available to him there in autumn 2014, and also to Bert Watteeuw for similarly investigating the Antwerp sources.

14 Edmond 1978–80, p. 88. I am grateful to John Guy for directing me to the Treasurer of the Chamber's accounts, the National Archives, E351/542.

15 George Vertue, 'Note Books', I, *Walpole Society*, XVIII (1929–30), p. 54.

16 See Christopher Brown, 'British Painting and the Low Countries 1530–1630', in Karen Hearn (ed.), *Dynasties: Painting in Tudor and Jacobean England 1530–1630*, exh. cat., Tate Gallery, London 1995, p. 28.

17 I am grateful to Eric Jan Sluijter and Eric Domela Nieuwenhuis, who suggested these names in 2003. In Michael Montias's *Art at Auction in 17th Century Amsterdam*, Amsterdam 2002 (p. 266, note 117, which relates back to p. 43) a list "of painters who bought lots [works of art] in or before 1619" includes one "Cornelis Jansz.". In this list Montias asterisked the names of "those who are presumed to have been apprentices …. They did not necessarily become master painters"; and he gave the name "Cornelis Jansz." an asterisk.

18 I am grateful to Katie Heyning for suggesting Mesdach, for whom see Noortje Bakker et al., *Masters of Middelburg. Exhibition in honour of*

Laurens J. Bol, Amsterdam 1984, pp. 102–06; Gortzius Geldorp also worked in Middelburg.

19 On Marcus Gheeraerts II, see Karen Hearn, *Marcus Gheeraerts II. Elizabethan Artist*, London 2002, and Edward Town, ' A Biographical Dictionary of London Painters, 1547–1625', *Walpole Society*, LXXVI (2014), pp. 87–88.

20 See *Dynasties* 1995, cat. no. 132, pp. 195–96, repr. in colour.

21 Formerly with the Weiss Gallery.

22 For the portrait of *Alice, Lady Le Strange*, see *Dynasties* 1995, cat. no. 144, p. 215, repr. in colour; for *Sir Hamon le Strange*, see *Family and Friends*, exh. cat., Castle Museum, Norwich, 1992, no. 18, pp. 84–85.

23 Buckeridge 1754, p. 389.

24 See *Dynasties* 1995, cat. no. 90, p. 143, repr. in colour.

25 John Murdoch, *Seventeenth-Century Miniatures in the Collection of the Victoria and Albert Museum*, London 1997, p. 43. For Larkin, see Sheila O'Connell, *William Larkin and the Earl of Dorset: A Portrait in Focus*, leaflet, Ranger's House, London, 1989; and Town 2014, p. 127.

26 For van Mierevelt, see Anita Jansen, Rudi Ekkart and Johanneke Verhave, *De portretfabriek van Michiel van Mierevelt (1566–1641)*, Delft 2011. The research project out of which this catalogue emerged found no reference to Cornelius Johnson in relation to van Mierevelt (information kindly supplied by Anita Jansen).

27 Vertue, 'Note Books', I, p. 54.

28 See *Dynasties* 1995, pp. 171 and 202.

29 On van Somer, see Town 2014, pp. 182–83.

30 On van Blijenberch, see Town 2014, p.178.

31 On Mytens, see (in Dutch) Onno ter Kuile, 'Daniel Mijtens "His Majesties Picture-Drawer"', *Nederlands Kunsthistorisch Jaarboek*, XX (1969), pp. 1–106, and Town 2014, p. 146.

32 On van Steenwijck, see Jeremy Howarth, *The Steenwyck Family As Masters of Perspective*, Turnhout 2009, and Town 2014, p. 183.

33 John Matthews, 'The Temple Family Portraits by Cornelius Johnson and Others', *Genealogists' Magazine*, XXXII, no. 1 (March 2013), pp. 5–13.

34 Another version of this portrait appeared at Christie's, London, on 7 April 1993 (lot 5).

35 Formerly with the Weiss Gallery, London; both oil on panel, 109.2 × 85 cm; his portrait inscribed *Aetatis Suae. 70* and hers *Aetatis Suae. 59* in the form of script mentioned.

36 See Edmond 1978–80, p. 89.

37 Ibid., p. 85.

38 London Painter-Stainers' Company, *Booke of Orders and Constitutions*, Guildhall MS. 5667/1/ fol.11, cited in Whinney and Millar 1957, p. 67.

39 Vertue, 'Note Books', I, p. 79, and II, p. 12, where he also noted that Theodore "was a lover of ease & his Bottle".

40 Formerly with the Weiss Gallery, London.

41 Edmond 1978–80, pp. 125, 203 note 296.

42 Signed in monogram, lower left: *C.J.fecit 1627*; see *The Courtly Image*, exh. cat., Weiss Gallery, London 2008, no. 18.

43 See *Dynasties* 1995, cat. no. 152, p. 228, repr. in colour.

44 Offered at Sotheby's, London, 10 November 1993 (lot 20); for Finch's biography, see entry by Louis A. Knafla, in *ODNB* 2004, IXX, pp. 572–76; and Andrew Thrush and John P. Ferris, *The History of Parliament: The House of Commons 1604–1629*, Cambridge 2010, pp. 271–79 ('Members D–J').

45 For Heath's biography, see entry by Paul E. Kopperman in *ODNB* 2004, XXVI, pp. 182–85; and Thrush and Ferris 2010, pp. 606–19.

46 See *Facing the Past*, exh. cat., Weiss Gallery, London 2011, no. 17.

47 See also Ulla-Satu Kakriainen's paper on the conservation of Johnson's signed and dated 1632–33 portrait of *Sir Thomas Savage, 1st Viscount Savage*, who served as Lord Chancellor to Queen Henrietta Maria, *Hamilton Kerr Institute Bulletin*, V (2014), pp. 110–20.

48 Vertue, 'Note Books', I, p.54.

49 At the same time, he paid 5 shillings to "the boy that brought itt": British Library Add. MSS 33,145, fol.107, cited in J.T. Cliffe, *The World of the Country House in Seventeenth-Century England*, New Haven and London 1999, p. 42.

50 Photograph in archive of National Portrait Gallery, London, with note on reverse: *oval, 30½ × 21 ins*. In 1899 this work belonged to Lord Pelham, Stanmer, Lewes, Sussex; later, it was sold by the Earl of Chichester at Christie's, London, 17 March 1937 (lot 71). A half-length portrait at Brocklesby Park, "30 × 25 in", bears a later inscription, bottom left, *Sir Thoˢ Pelham, of Sussex.*, according to a note in the Oliver Millar Archive, Paul Mellon Centre for British Art (viewed in August 2014).

51 Charlotte C. Stopes, 'Daniel Mytens in England', *Burlington Magazine*, XVII (1910), p. 160.

52 Sotheby's, London, 8 March 1989 (lot 23), signed and dated, lower right, *C.J. fecit / 1629*.

53 On Mytens's portraits of Hamilton, see Ter Kuile 1969, pp. 67–69.

54 On Mytens's portraits of Charles I, see Ter Kuile 1969, pp. 53–62.

55 See note 2 above: Millar 1948.

56 Sold Christie's, London, 'A Life's Devotion: The Collection of the Late Mrs T.S. Eliot' sale, 20 November 2013 (lot 165); now UK private collection. According to Prof. P.A. Christensen (email of 9 July 2014), the inscription on the back, *Jacobus Esplein fecialis a Marchemond 15 Dec 1630*, translates as: 'James Esplin, Marchemond (i.e. Roxburgh Castle) Herald, 15 December 1630', and James Esplin was indeed made Marchemond Herald (one of the four Scottish heralds) to Charles 1 on 15 December 1630.

57 'Gleanings from the Records of James I and Charles I', *Burlington Magazine*, XXIII (1913), p. 280; PRO LC 5/132, f. 311, cited in Stefanie Kollmann, *Niederlandische Kunstler und Kunst im London des 17. Jahrhunderts*, Hildesheim 2000, p. 219.

58 Karen Hearn (ed.), *Van Dyck & Britain*, exh. cat., Tate Britain, London, 2009, cat. no. 17, pp. 68–69.

59 Finberg 1922, no. 56: oil on panel, signed in bottom right spandrel: *C.J. / fecit 1633*; according to Finberg, the second figure 3 "was at first a '2'". The work was subsequently

included in the Barrett-Lennard sale, Belhus, 15 May 1923 (lot ?879) and its present location is unknown.

60 Both now in private collections.

61 See Barnes et al. 2004, no. IV.A11, p. 632. Mezzotints were subsequently made after that image by Wallerant Vaillant (1623–1677) and Abraham Blooteling (1640–1690); see New Hollstein, V, no. 420, pp.129–31, as "*Ant: van Dijk Pinx*".

62 See *Van Dyck & Britain* 2009, cat. no. 20, p. 73, repr. in colour.

63 Information supplied by Mrs Celia Curnow, The Virtual Hamilton Palace Trust, May 2008. By 1759 the painting was listed in another Hamilton inventory as "King Charles II with a dog on copper by Vandyke" – which was still its attribution at the time of its sale in 1882.

64 Oil on copper, 25.5 × 21 cm, see Röding et al. 2003, pl. I (facing p. 128), repr. in colour; see also *A Noble Visage: A Catalogue of Early Portraiture*, exh. cat., Weiss Gallery, London, cat. no. 24.

65 Oil on panel, 49.5 × 43 cm, branded with the cipher of Charles I on the reverse; Geoffrey Coldham Esq., by whom sold Sotheby's, London, 8 March 1989 (lot 24).

66 For Houckgeest, see the entry by Walter Liedtke in *The Grove Dictionary of Art*, 1996, XIV, pp. 795–96; it is unclear how (or whether) this artist was actually in London, but the painting is mentioned in Abraham van der Doort's inventory of Charles I's collection: see Oliver Millar, 'Some Painters and Charles I', *Burlington Magazine*, CIV (1962), p. 330.

67 NPG nos. 5103, 5104 and 5105.

68 The National Archives, LC 3/1 f.9, cited in Kollmann 2000, p. 219.

69 *Van Dyck & Britain* 2009, cat. no. 16, p. 63.

70 Ibid., cat. no. 54, p. 120.

71 Robyn Asleson and Shelley M. Bennett, *British Paintings in the Huntington*, New Haven and London 2001, pp. 214–15; *Van Dyck & Britain* 2009, cat. no. 90, pp. 174–15.

72 For example, a portrait said to be of Sir Kenelm Digby and said to be signed by Johnson and dated 1626, sold Sotheby's, London, 6 March, 1957 (lot 161) and in 1959 in the collection of Dr Jerome P. Webster (annotated photograph in Heinz Archive, London). Johnson also used this form of dress for a miniature of an unknown young man, "signed with initials c.1638", oil on copper, oval, 11.4 cm, Sotheby's, 20 July 1981 (lot 4).

73 Asleson 2001, pp. 214–15: see Barnes et al. 2004, cat. no. IV.201, p. 586, and IV.A33, p. 640.

74 For an account of the theme of melancholy in early seventeenth-century English portraiture, see Roy Strong, 'The Elizabethan Malady: Melancholy in Elizabethan and Jacobean Portraiture', *Apollo*, LXXIX (1964), pp. 264–69 (reprinted in Roy Strong, *The Tudor and Stuart Monarchy: Pageantry, Painting and Iconography*, II, Woodbridge 1995, pp. 295–302) and Tarnya Cooper, *Citizen Portrait*, New Haven and London 2012, pp. 177–78 and 188–93.

75 Tessa Murdoch (ed.), *Boughton House*, London 1992, p. 219, pl. 46 and repr. in colour facing p. 104; Emilie E.S. Gordenker, *Anthony van*